Monterey Peninsula

IMPRESSIONS

FARCOUNTRY
PRESS

photography by James Randklev

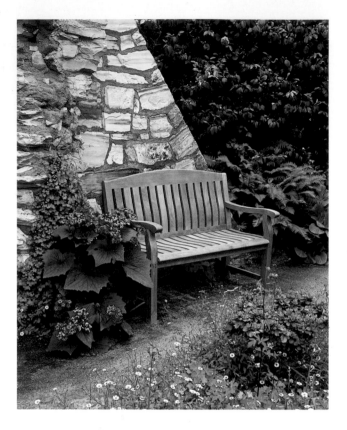

Left: A flower-bedecked sitting area in the Monterey Historic District. Both the Spanish and Mexican capital of California, Monterey is filled with eighteenth- and nineteenth-century buildings from the Spanish colonial era.

Right: Windswept surf crashes over the rocks at Pacific Grove.

Title page: A charming garden surrounds the adobe Stevenson House, located in the Monterey Historic District, where Robert Louis Stevenson stayed in 1879. While in Monterey, Stevenson wrote *The Old Capitol*.

Front cover: Flowers adorn the hillside leading to the white sands of Carmel Beach.

Back cover: This kelp forest threaded by fish is a perennial favorite at the Monterey Bay Aquarium. Opened in 1984 at the end of Cannery Row, the aquarium houses 550 different species that eat as much as 305 pounds of food a day.

ISBN 13: 978-1-56037-346-9
ISBN 10: 1-56037-346-6
Photography © 2005 by James Randklev
© 2005 Farcountry Press

For more information about our books write Farcountry Press, P.O. Box 5630, Helena, MT 59604; call (800) 821-3874; or visit www.farcountrypress.com.

Created, produced, and designed in the United States.
Printed in China.

09 08 07 06 05 1 2 3 4 5

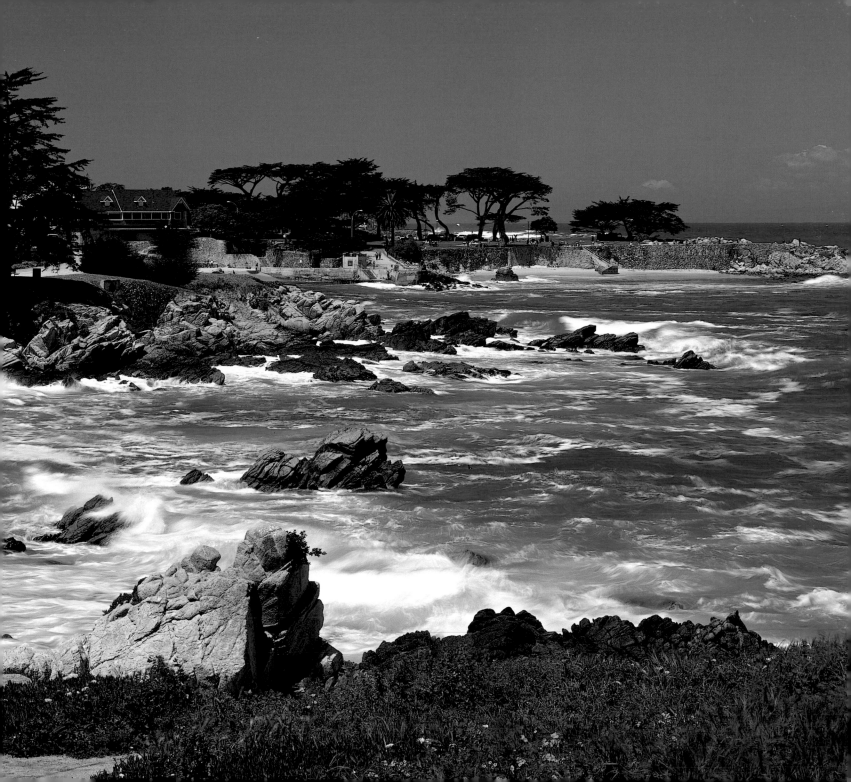

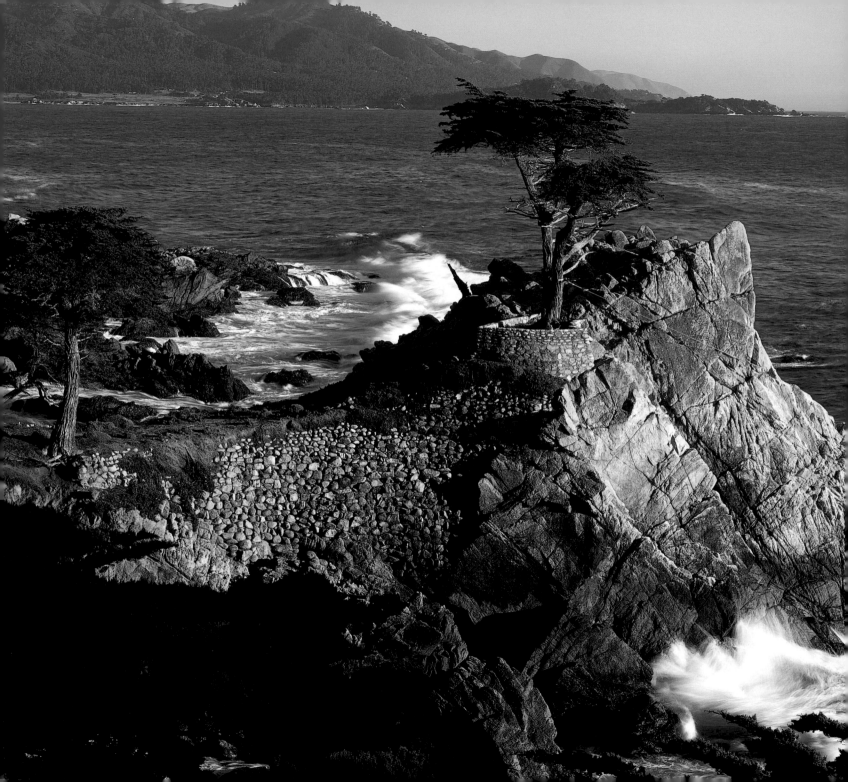

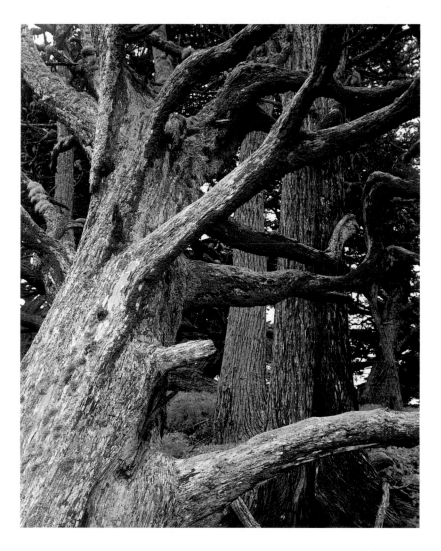

Above: Weathered by Pacific Ocean storms, these twisted lichen-encrusted cypress trees are like sculpture along Carmel beaches.

Left: A trademark of the Pebble Beach Company, the aptly named Lone Cypress is one of the most photographed sites along the 17-Mile Drive that borders Pebble Beach.

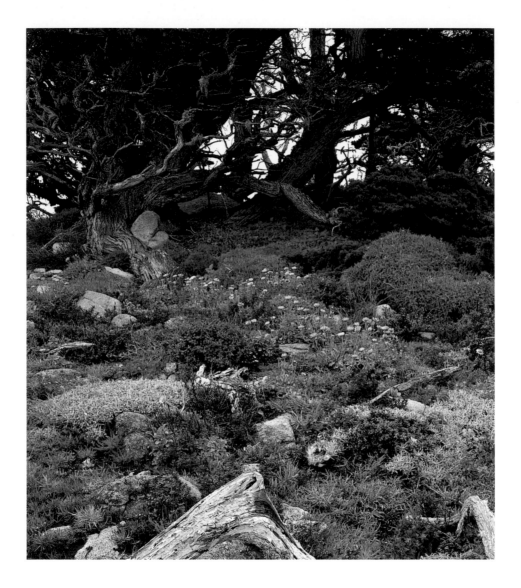

Above: A mosaic of wildflowers among Monterey cypress trees at Point Lobos State Reserve, which landscape artist Francis McComas described as "the greatest meeting of land and water in the world."

Right: Carmel is known for its quaint shops, galleries, and restaurants. At the turn of the century, it was a mecca for artists, writers, actors, and playwrights, who were intent on creating an intellectual and cultural oasis.

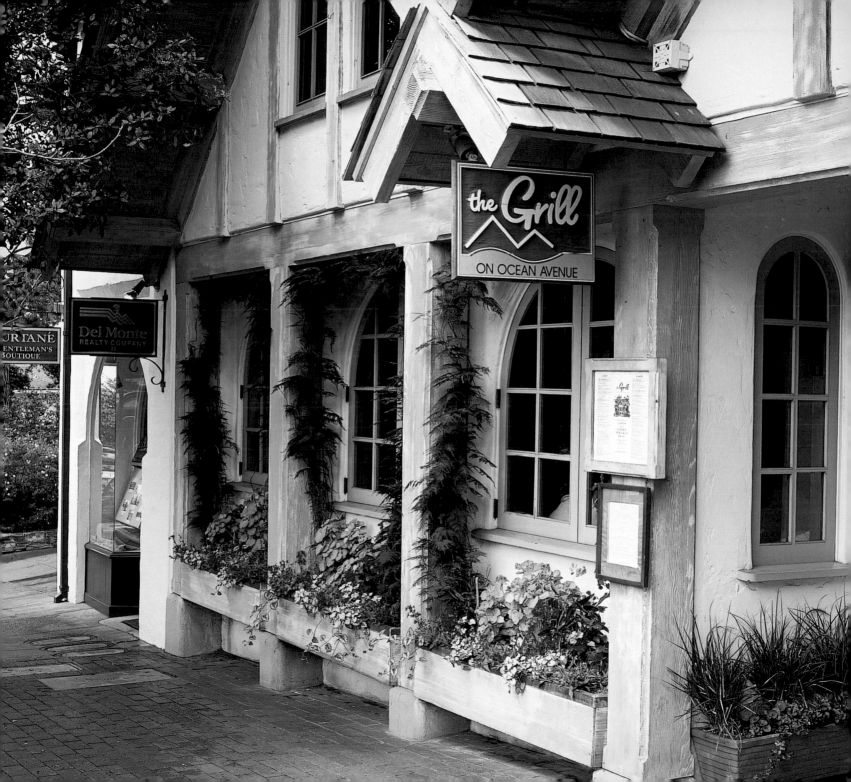

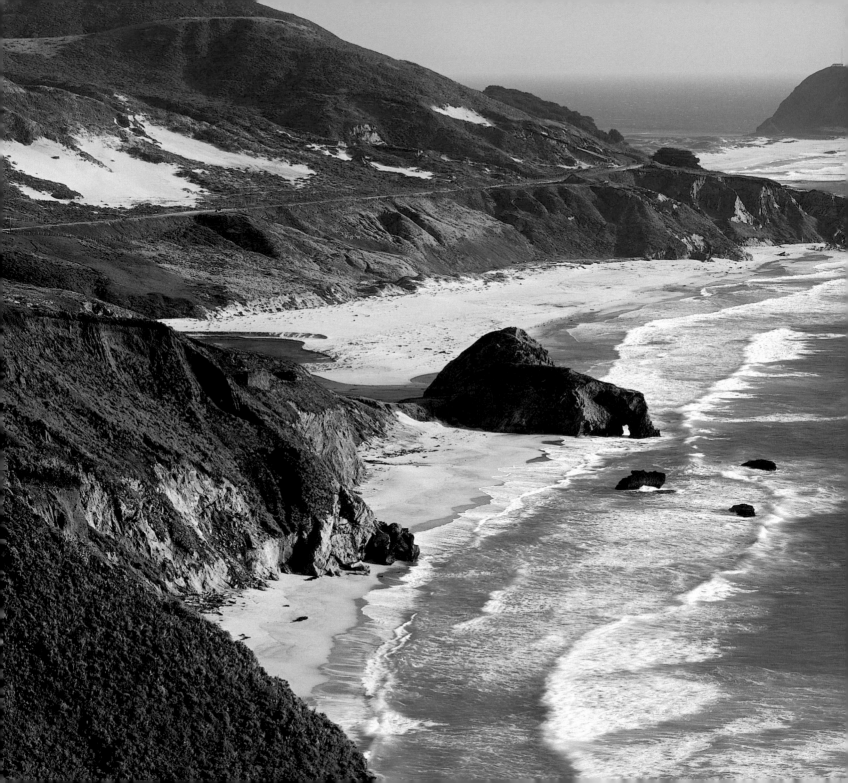

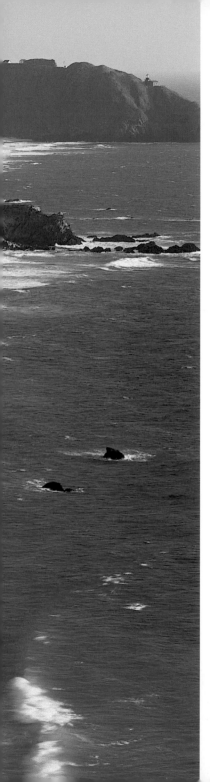

Left: Sweeping view of Point Sur and its namesake lighthouse.

Below: Exposed tidal seaweed lies along a rocky beach at Point Lobos State Reserve.

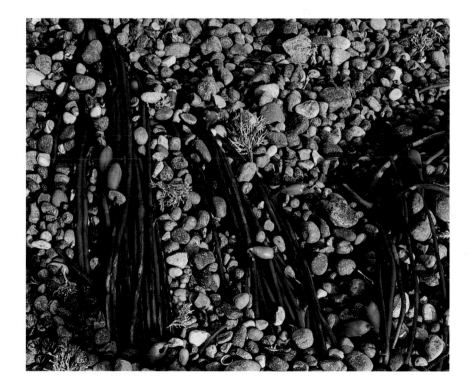

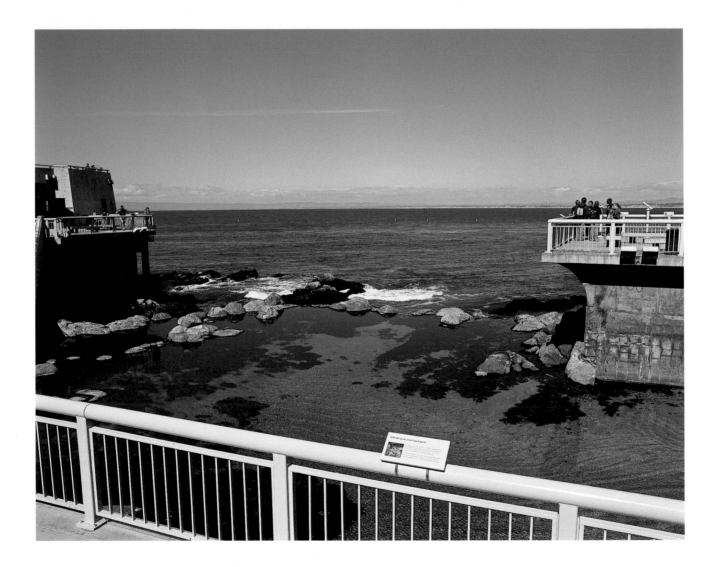

Above: From this outside deck at the Monterey Bay Aquarium, visitors can spot one of the 30 different species of marine mammals, ranging from the 5-foot-long otter to the 100-foot-long blue whale.

Facing page: Visitors watch a leopard shark swim in the 28-foot-high Kelp Aquarium, one of the tallest aquarium exhibits in the world.

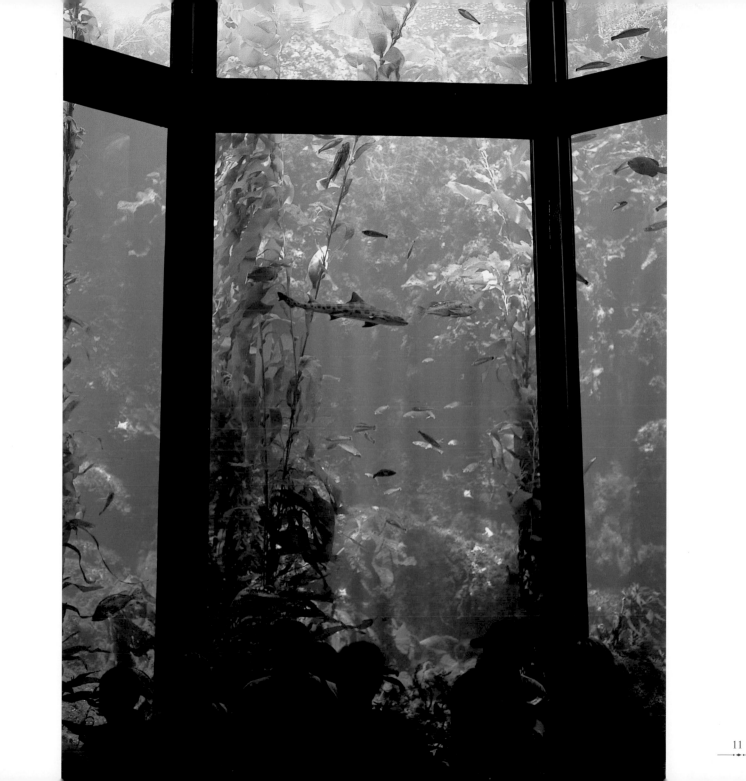

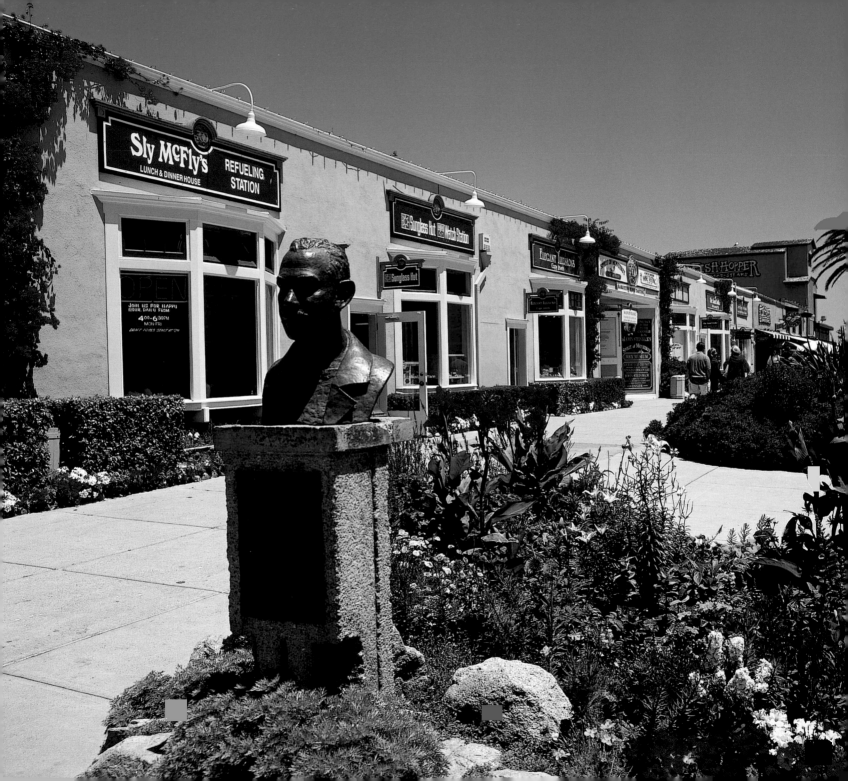

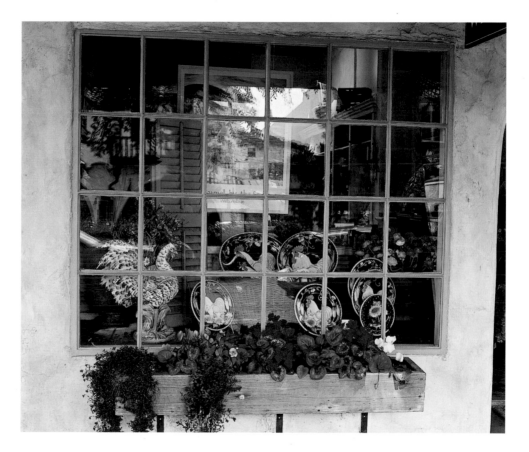

Above: A storefront window displays rooster crockery along Ocean Avenue, where the buildings exhibit elements of Spanish mission and English rustic architectural styles.

Left: This John Steinbeck bust on Cannery Row near Fisherman's Wharf commemorates the writer who lived from 1902 to 1968 and wrote extensively about California in his fiction.

Following pages: Pleasure boats anchored in harbor near Fisherman's Wharf.

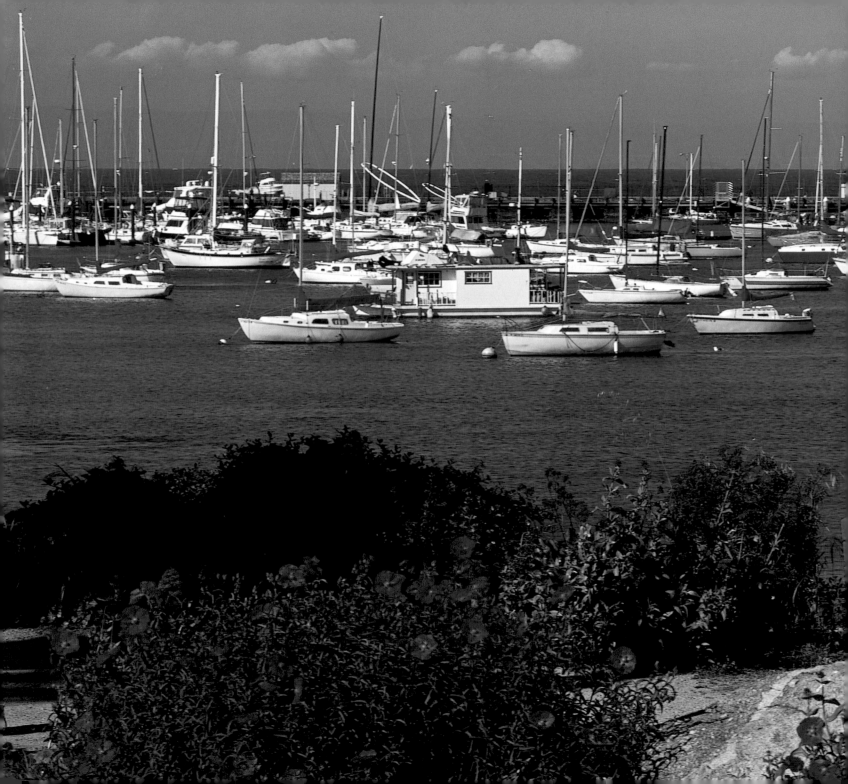

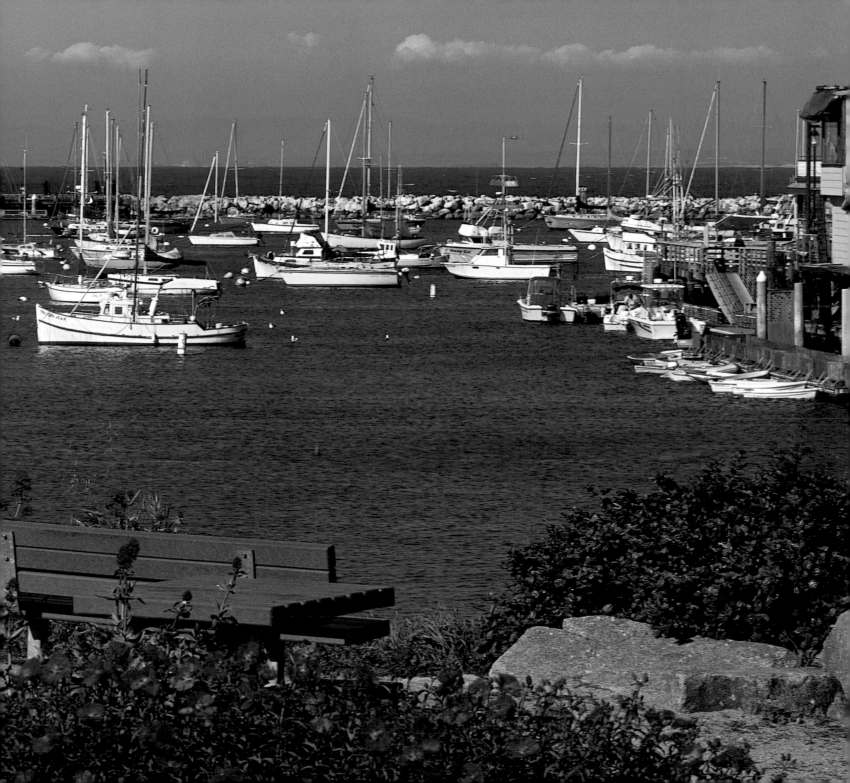

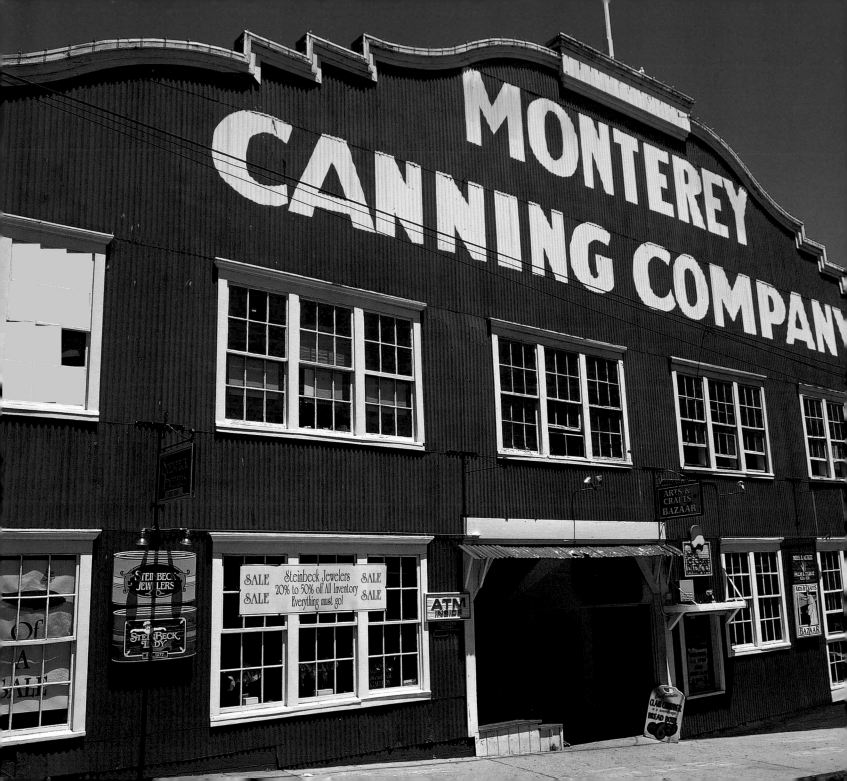

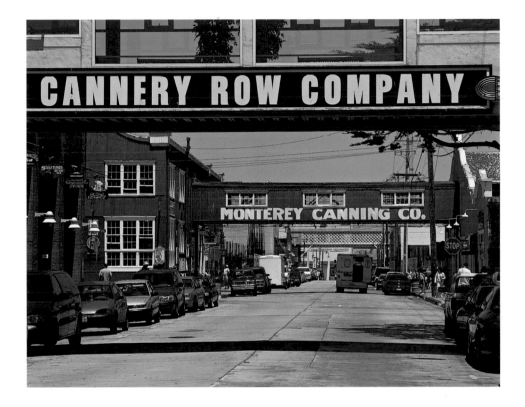

Above: Historic Cannery Row began in 1903 when Frank Booth, the "father of the sardine," constructed Monterey's first large-scale cannery in the harbor.

Left: Cannery Row was made famous by John Steinbeck's 1945 novel of the same name.

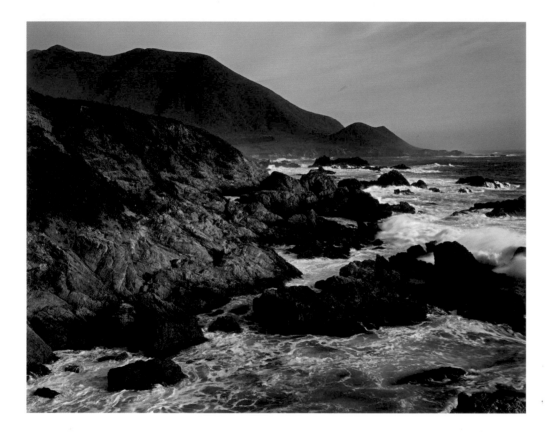

Above: Waves crash against the rugged Big Sur coastline.

Right: At Point Lobos State Reserve, a bat starfish waits on a bed of sandstone for the incoming tide.

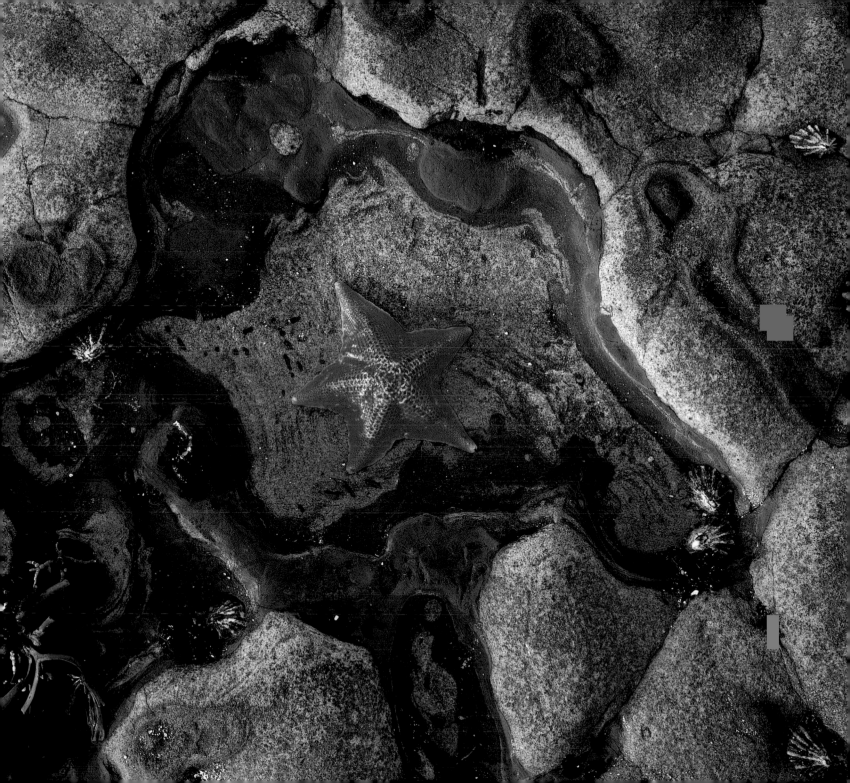

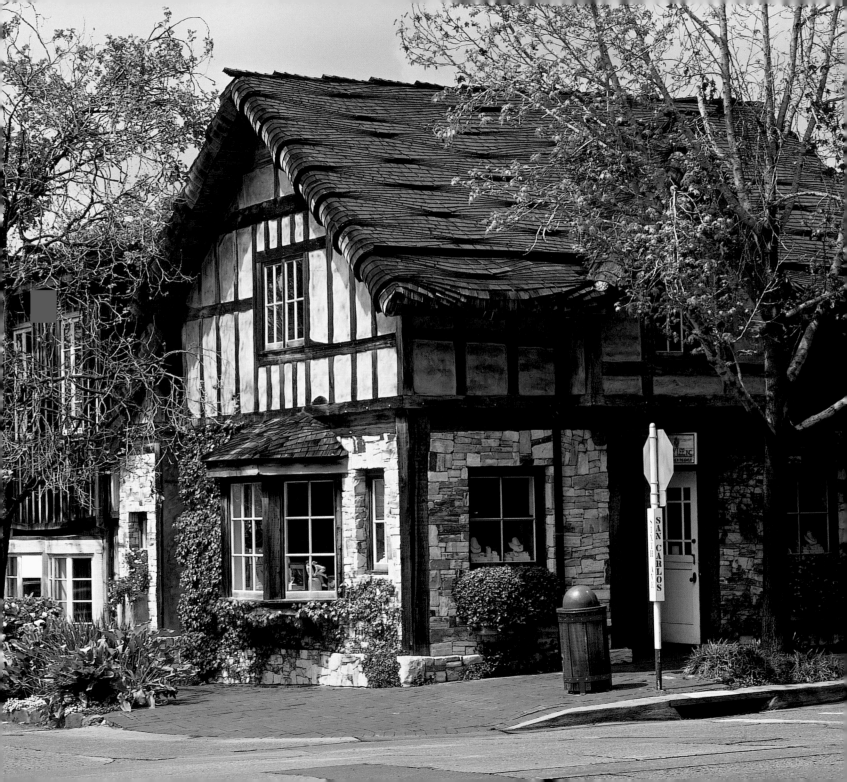

Facing page: Fairytale cottages in Carmel, such as this one, give the town the look of an English country village.

Below: Golfers on the 18-hole Pacific Grove Municipal Golf Links, with the Point Pinos Lighthouse in the distance.

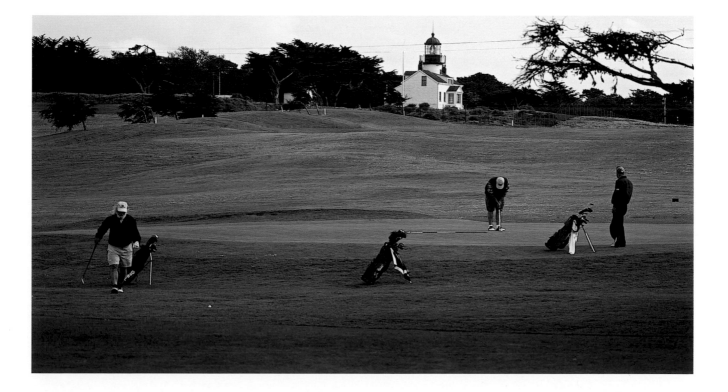

Right: At Big Sur, the sun's late-afternoon light bathes the iceplants along a cliff in gold.

Below: Bits of seaweed and algae are strewn on the beach, washed up by the high tide at Point Lobos State Reserve, which is considered to be one of California's richest marine habitats.

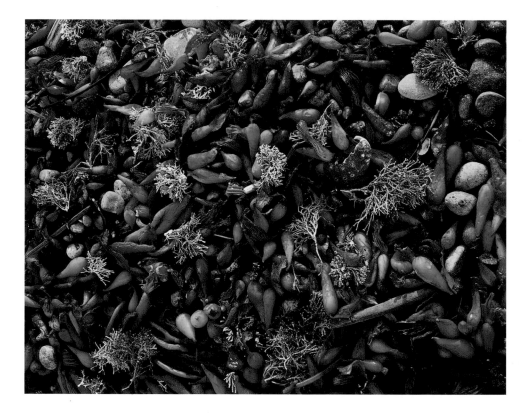

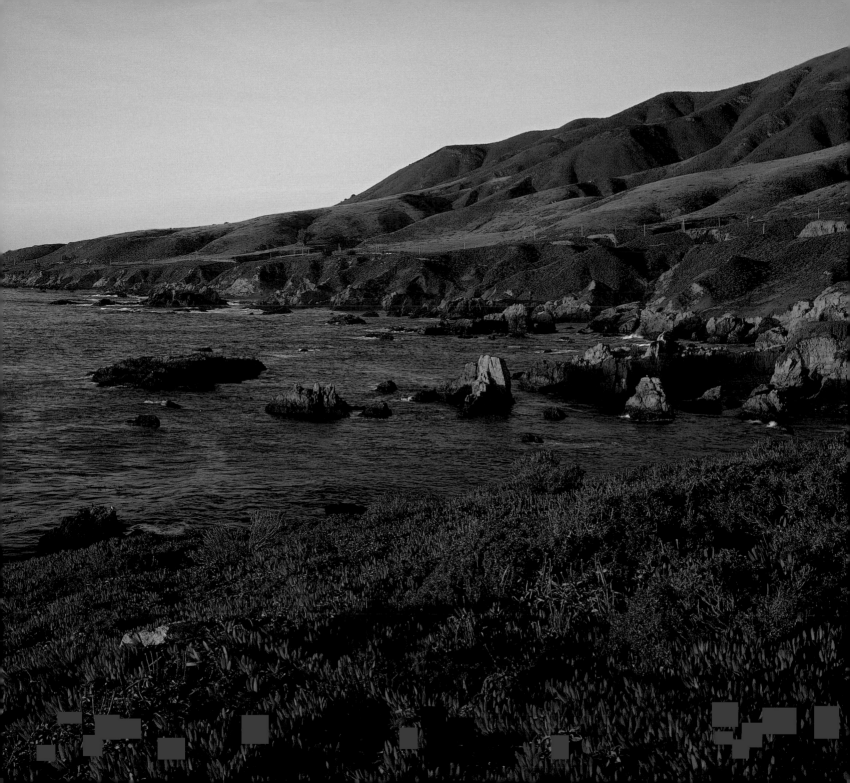

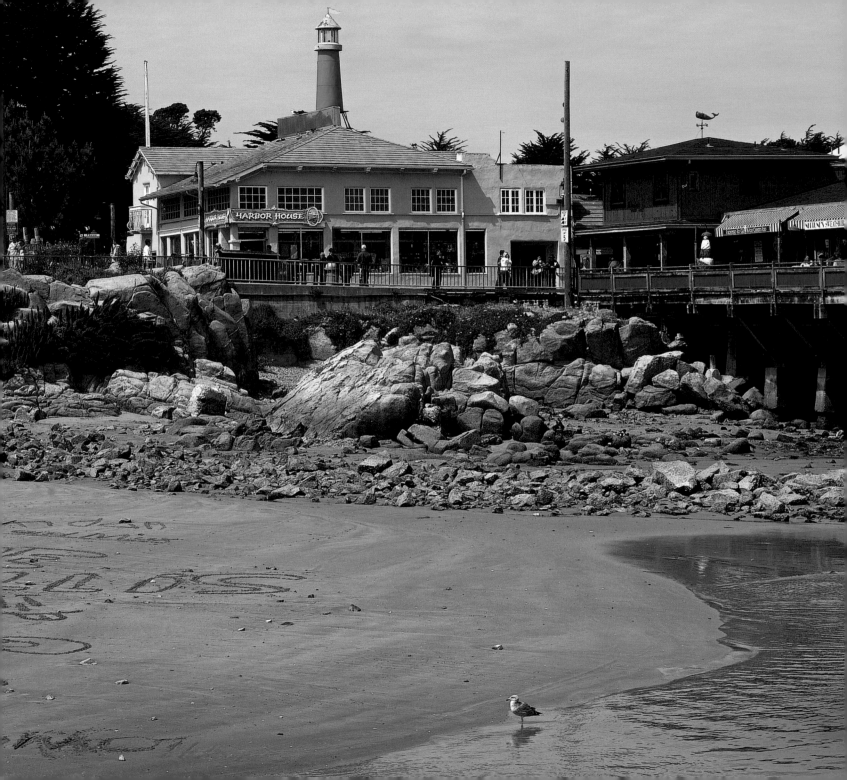

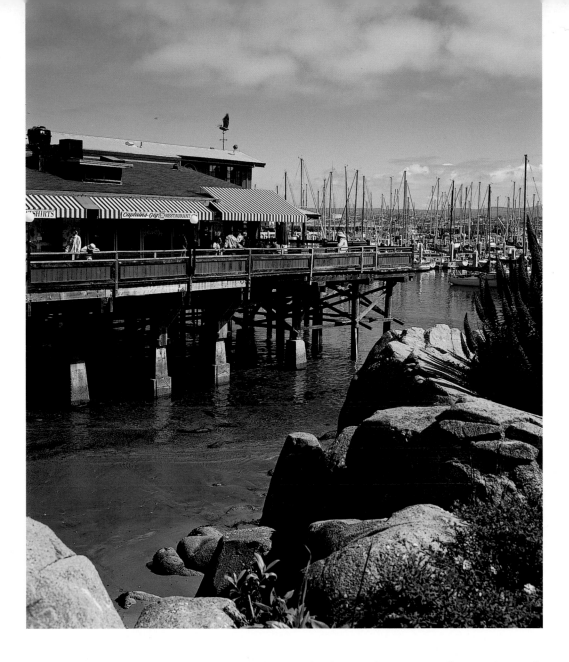

Above: The picturesque Fishman's Wharf was built in 1916 by the city of Monterey. Sailboats now crowd the harbor that was once plied by craft ranging from Spanish galleons to steamships.

Left: Where tons of sardines were once caught and canned, the Wharf has now become a tourist haven where visitors enjoy area restaurants, gift shops, and art galleries.

Right: This popular pathway along Pacific Grove Beach provides a stunning vista of the Pacific Ocean.

Below: In the Monterey Old Town historic district, part of the Monterey State Historic Park, flowers adorn an old stone wall. The U.S. flag was first officially raised in California in Monterey on July 7, 1846, bringing 600,000 square miles, including California, into the Union.

Following pages: Waves crash dramatically against the rocky shore at Pacific Grove.

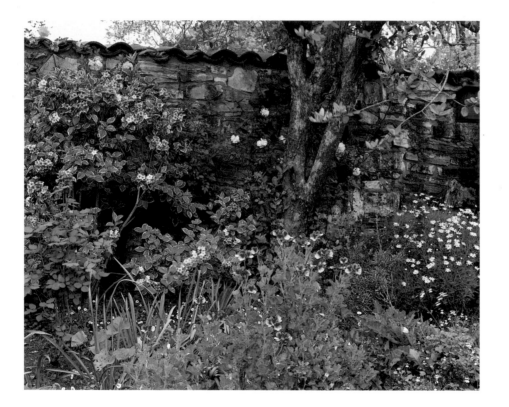

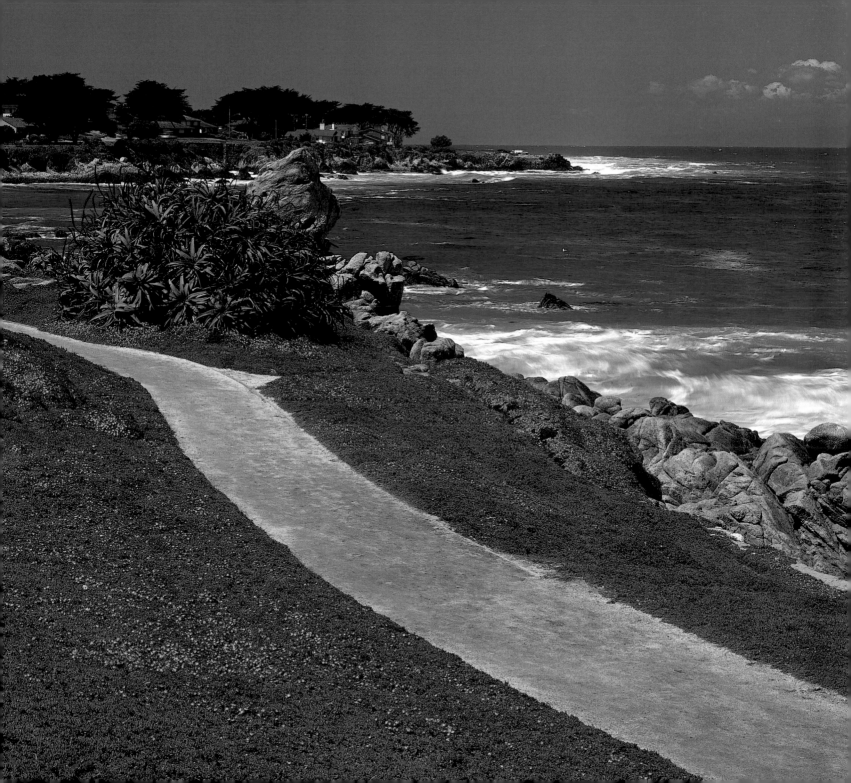

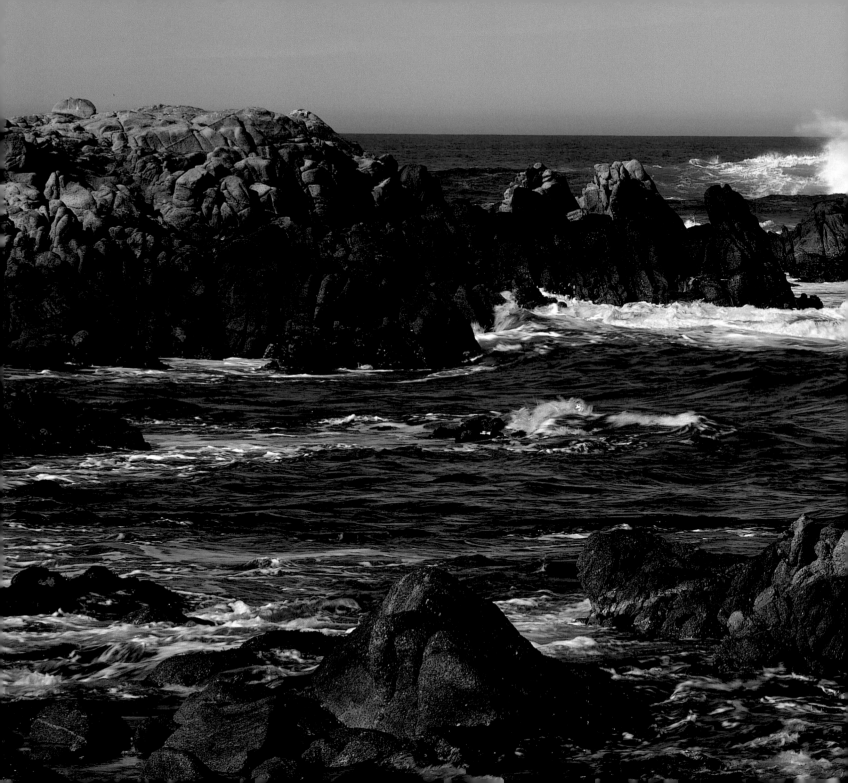

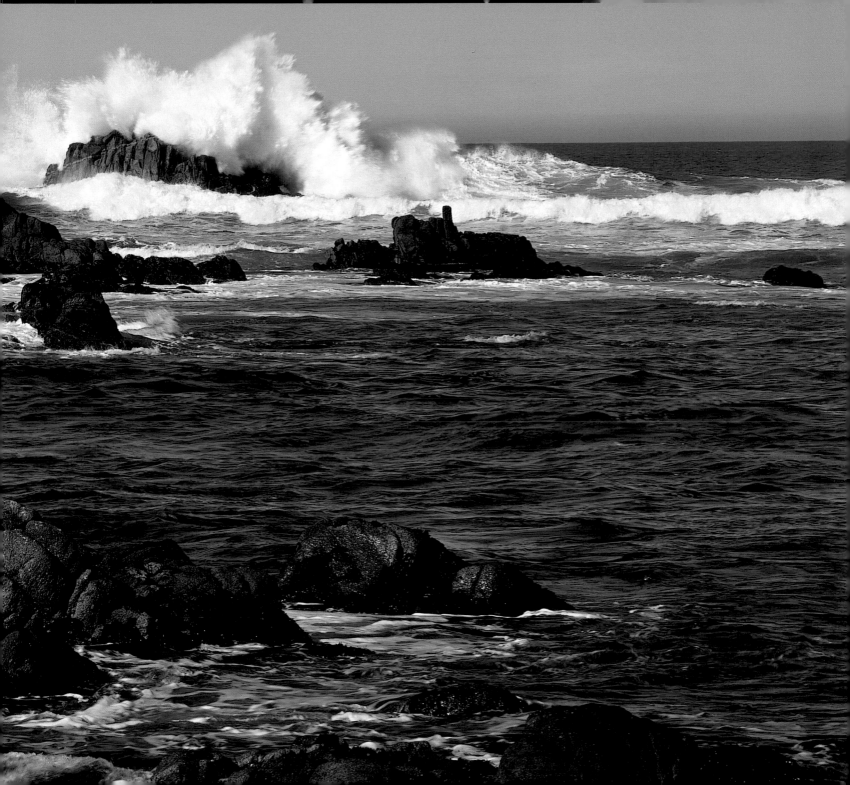

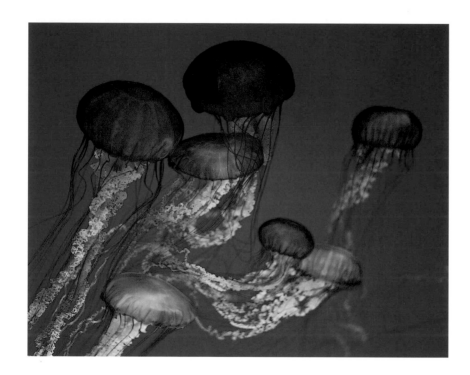

Above: Sea nettle jellyfish swim in the blue waters of the one-million-gallon Outer Bay Gallery at the Monterey Bay Aquarium.

Right: Located in the Monterey Old Town historic district, the 1842 Casa Soberanes Adobe was built with adobe bricks and wood and has become known as the House of the Blue Gate.

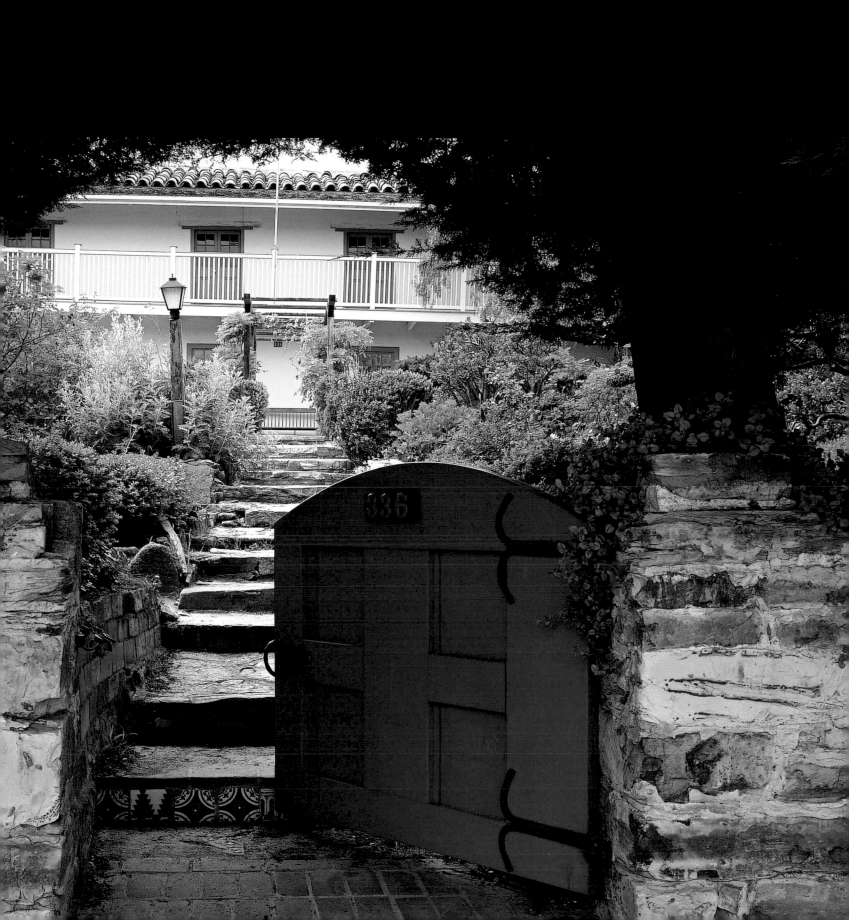

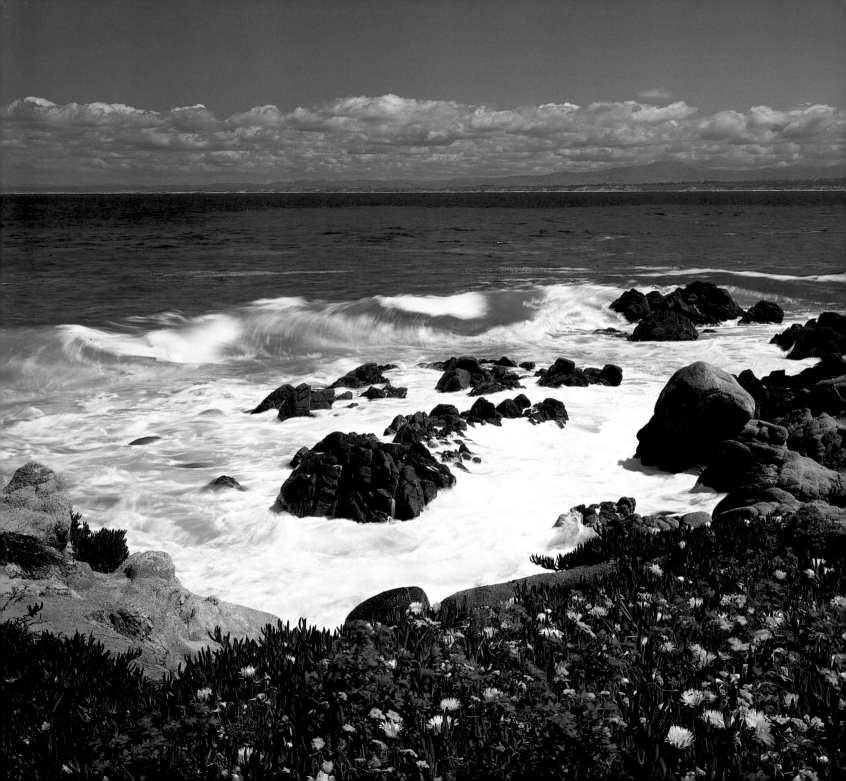

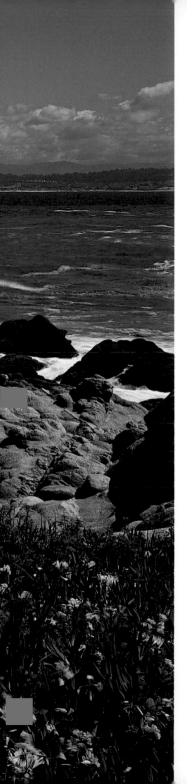

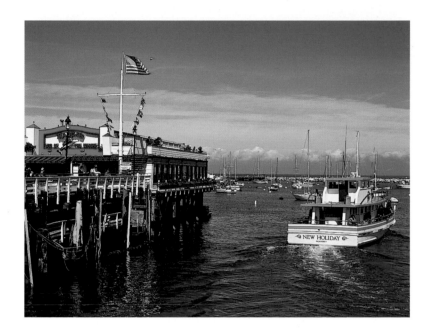

Left: Harbor boat cruises ply the calm waters of Monterey Bay.

Below: Sea kayakers paddle their boats among the anchored sailboats in Monterey Bay. The kelp forest canopy of the Monterey Bay National Marine Sanctuary along Cannery Row is a favorite destination for sea kayakers.

Left: A clearing spring storm creates heavy surf in this normally calm bay at Pacific Grove.

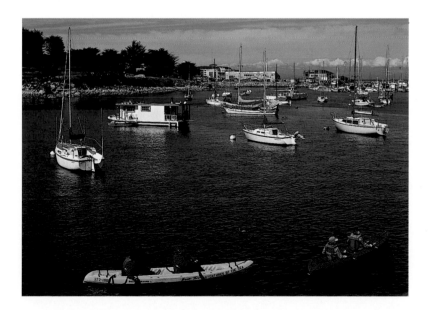

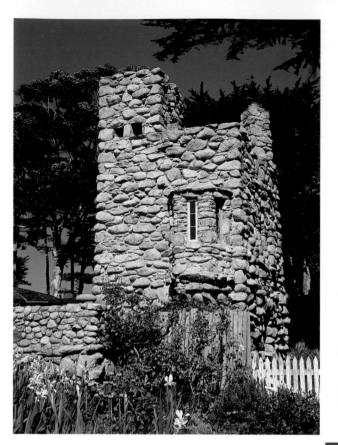

Right: This classic view along Cypress Trail has inspired writers, painters, and photographers who visit Point Lobos State Reserve.

Below: Located on the Monterey Peninsula at Pacific Grove, the Point Pinos Lighthouse was built in 1855 and is the oldest operating lighthouse on the West Coast. A whale-oil lantern was once the original source of light; today it is a 1,000-watt electric bulb, amplified by the lenses and prisms to produce a 50,000-candlepower light.

Above: The poet John Robinson Jeffers (1887 to 1962) built Hawk Tower and the nearby Tor House of granite stone, making "stone love stone."

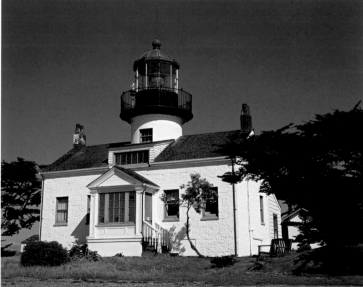

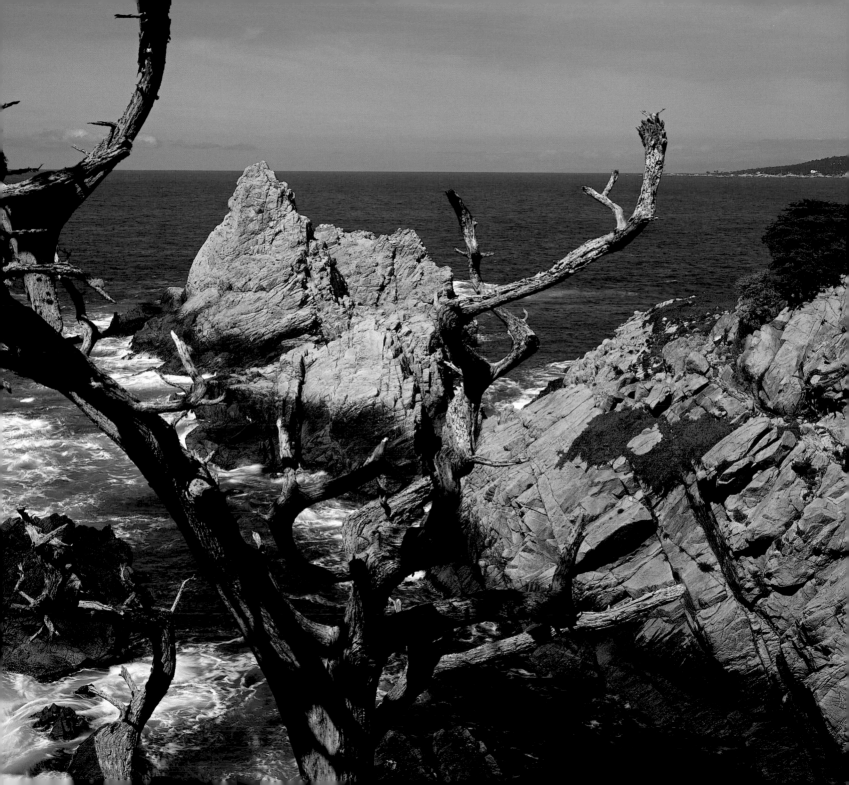

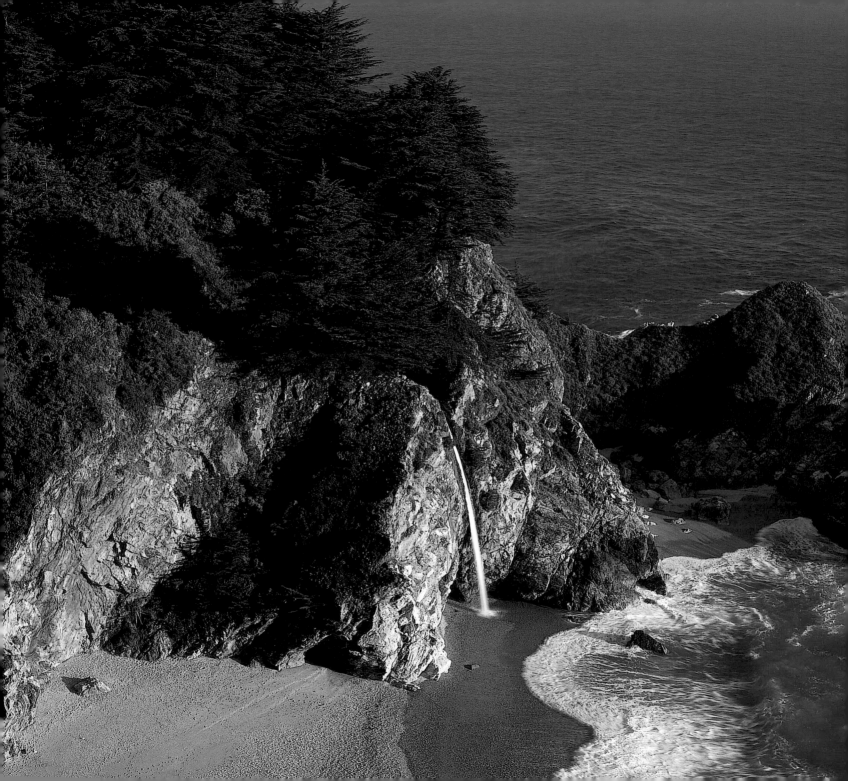

Left: A waterfall plunges 80 feet into the ocean at Julia Pfeiffer Burns State Park. Named after a well-respected pioneer woman, the park stretches from the Big Sur coastline up into the 3,000-foot ridges.

Below: At the 1,006-acre Pfeiffer Big Sur State Park south of Carmel, giant coastal redwoods tower over the maples, oaks, sycamores, and willows.

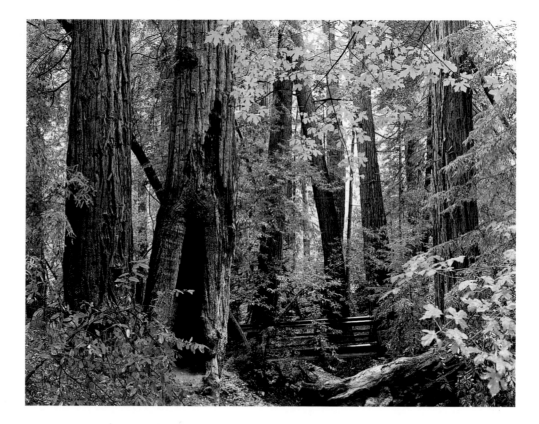

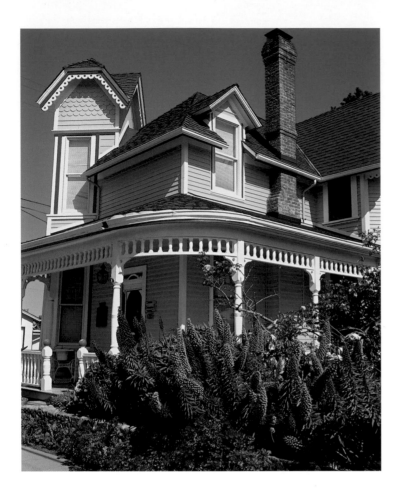

Facing page: John Steinbeck was born and raised in this 1897 Victorian house in Salinas. It was here that Steinbeck began his writing career with stories such as "The Red Pony."

Below: This bronze statue of Steinbeck stands in front of the Salinas Public Library that is named for the 1962 Nobel Prize–winning author.

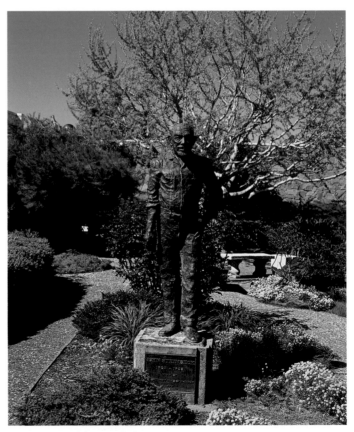

Above: This two-story Victorian home is in Pacific Grove, a community that was originally established in 1875 as a Methodist Episcopal church camp.

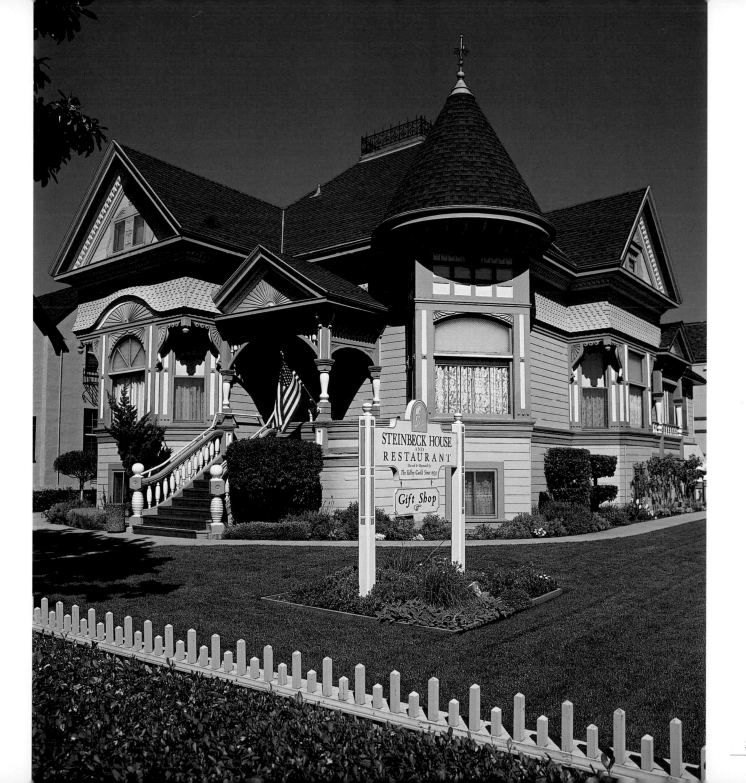

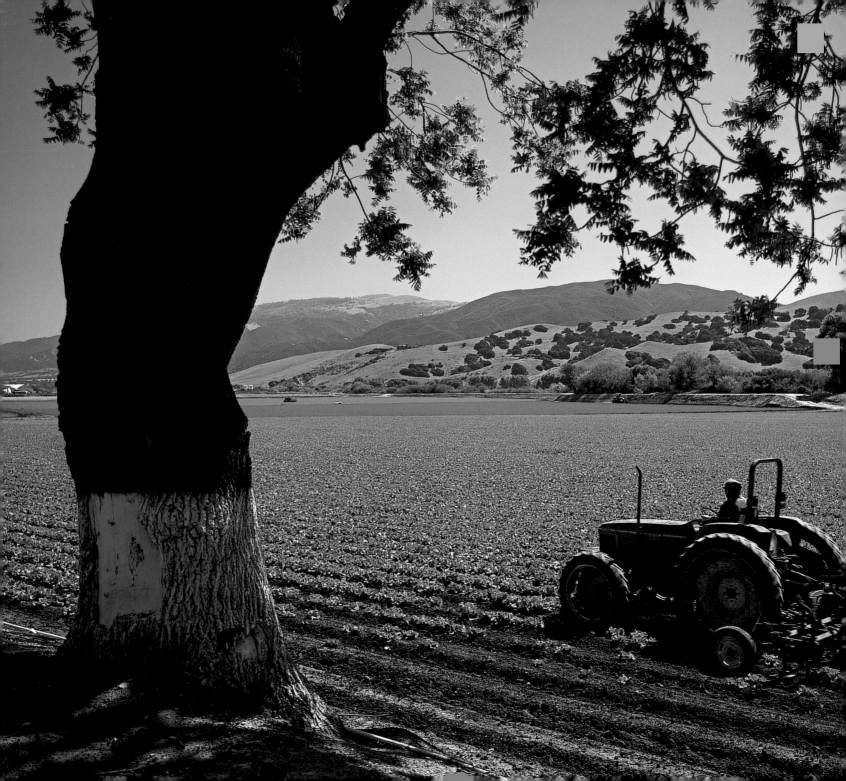

Left: A tractor tills the rich, fertile soil of Salinas, where much of the California's produce is grown.

Below: A field of lupine blossoms in spring along Highway 68, which connects the Monterey Peninsula to Route 101 in Salinas.

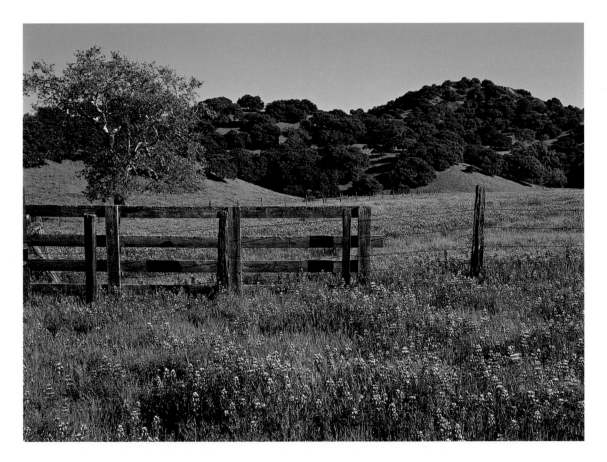

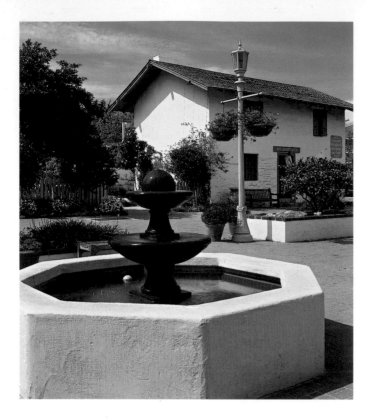

Left: The Casa del Oro Adobe was a general merchandise store called The Boston Store. It was also known as the House of Gold because it was rumored that miners kept their money there.

Right: Artichokes grow in Cooper-Molera Garden. Built the 1920s, the gardens are part of a 3-acre complex that depicts Monterey living in the mid-1800s with living history demonstrations, farm animals, and historic gardens.

Right: The reflection pool in the courtyard of the Memory Garden. Located at the 1847 Pacific House Adobe, the walled garden is the setting for the annual La Merienda celebration in June.

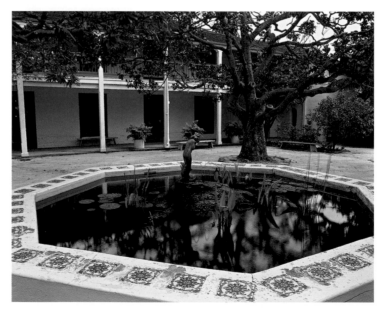

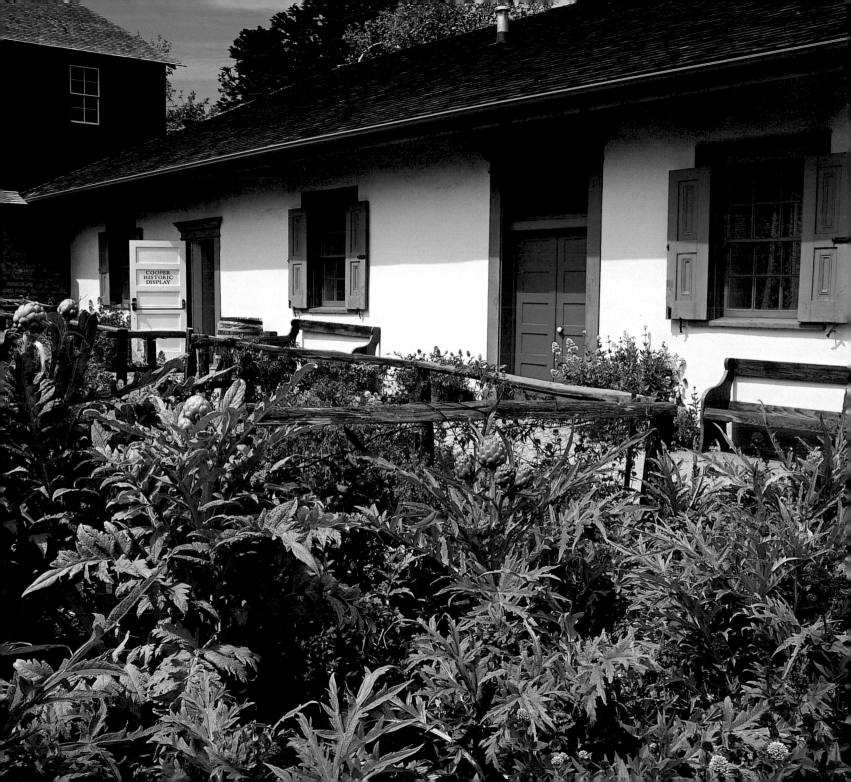

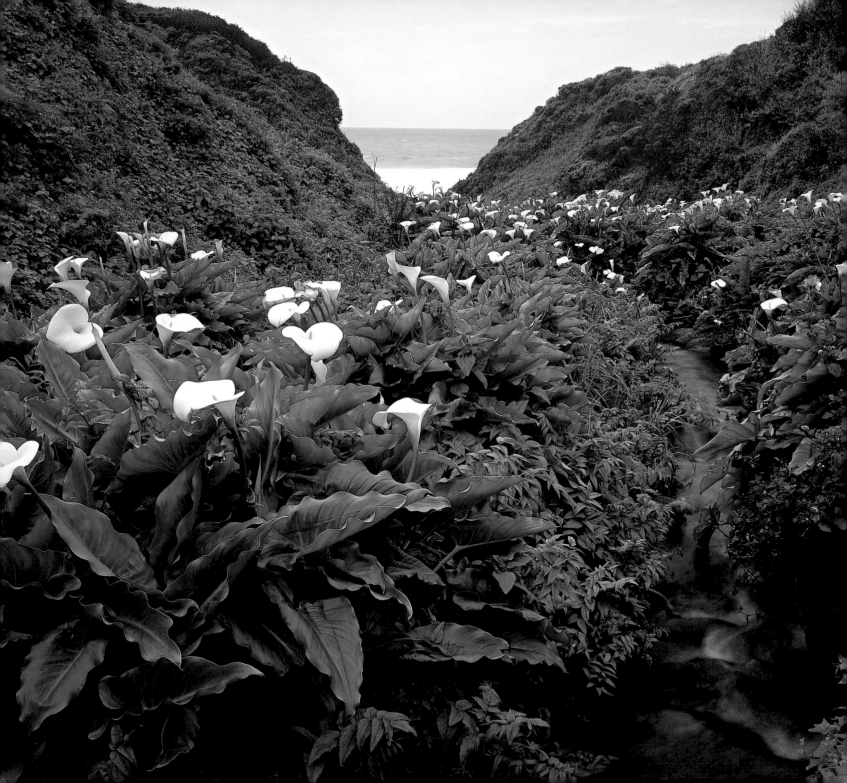

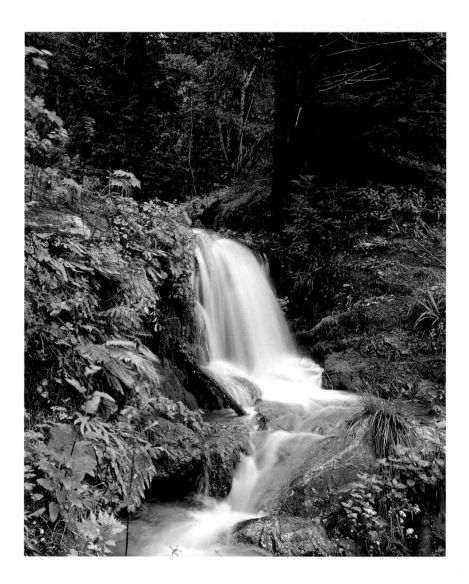

Above: A seasonal mountain stream flows through old-growth redwoods in Pfeiffer Big Sur State Park, named for Michael and Barbara Pfeiffer, early area settlers.

Left: Graceful calla lilies grow profusely along the streambeds at the 2,879-acre Garrapata State Park.

Left: The courtyard of the 1770 Carmel Mission, or Mission San Carlos Borromeo de Carmelo, the second mission established in California by Father Junipero Serra. After he died, Serra was buried under the altar of the stone church.

Right: La Playa Hotel and Cottages-by-the-Sea in Carmel, originally established in 1905, features elegant accommodations and lavishly landscaped grounds.

Below: There are numerous quaint inns in Carmel or Camel-by-the-Sea, as it is also known. Carmel was named by the Spanish for the Carmelite friars who accompanied them.

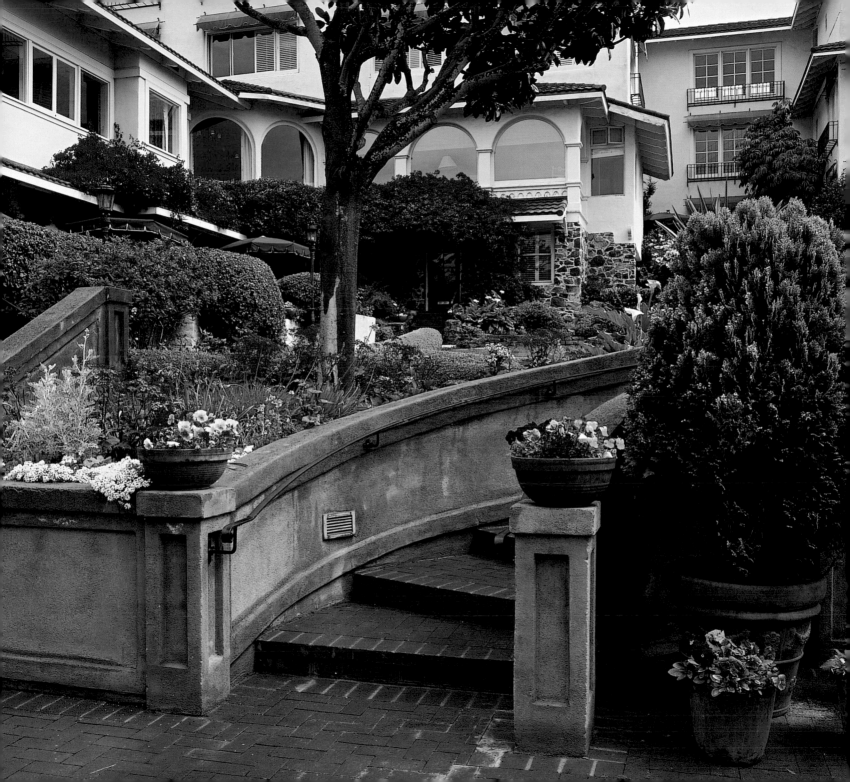

Left: The Hottentot fig, a native of South Africa, was planted along the California coastline to control erosion.

Below: An abalone shell lies half-buried in sand.

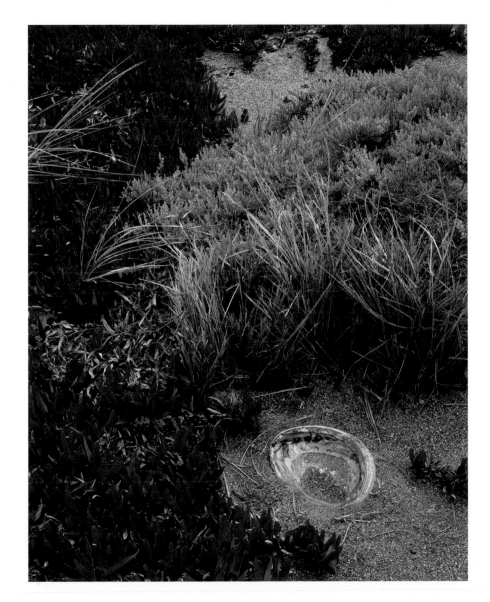

Right: A misty sunset reddens the coastline of Big Sur, where coastal mountains plunge dramatically into the Pacific Ocean.

Below: The California poppy, once cherished by area Indians as a source of food, became the state flower in 1903.

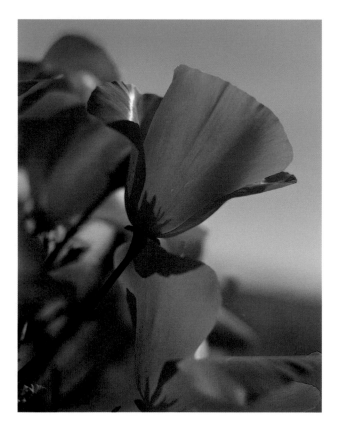

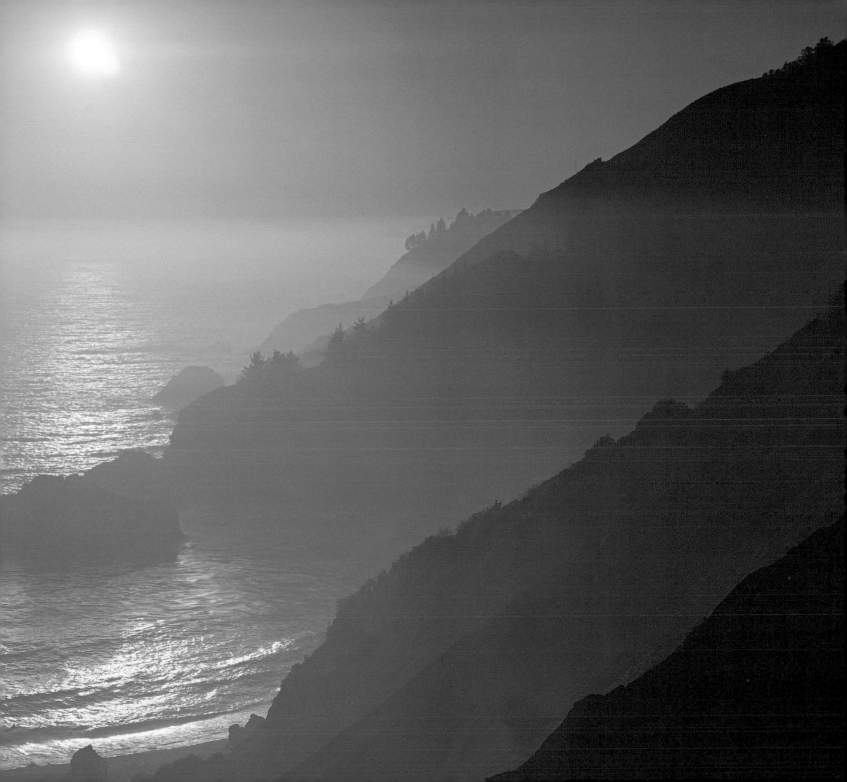

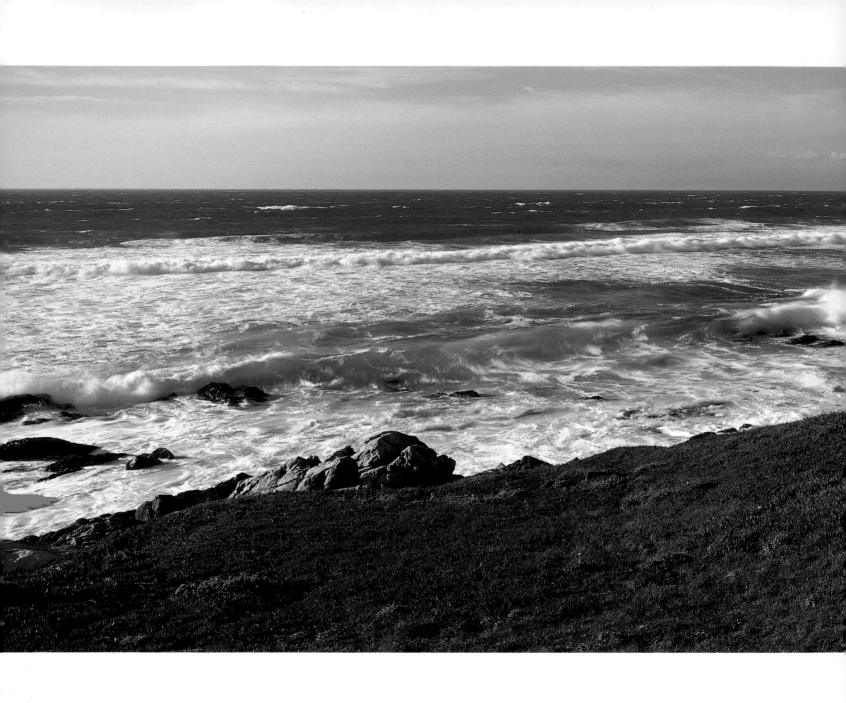

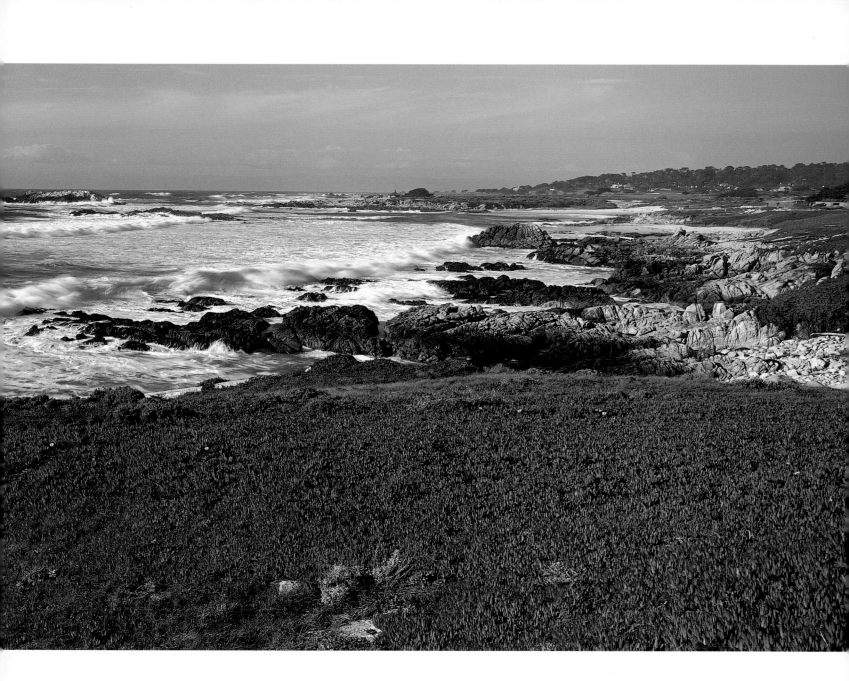

The 17-Mile Drive at Pebble Beach hugs the coastline where brown pelicans,
black cormorants, and California sea otters can often be seen.

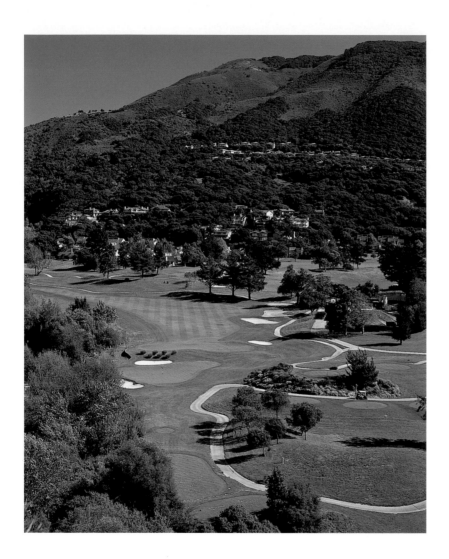

Above: Tucked in the hills of Carmel Valley, this 18-hole golf course, with its lush green links bordered by live oaks, offers beautiful scenery and a challenging course.

Right: Cypress trees frame a view of Monterey Bay.

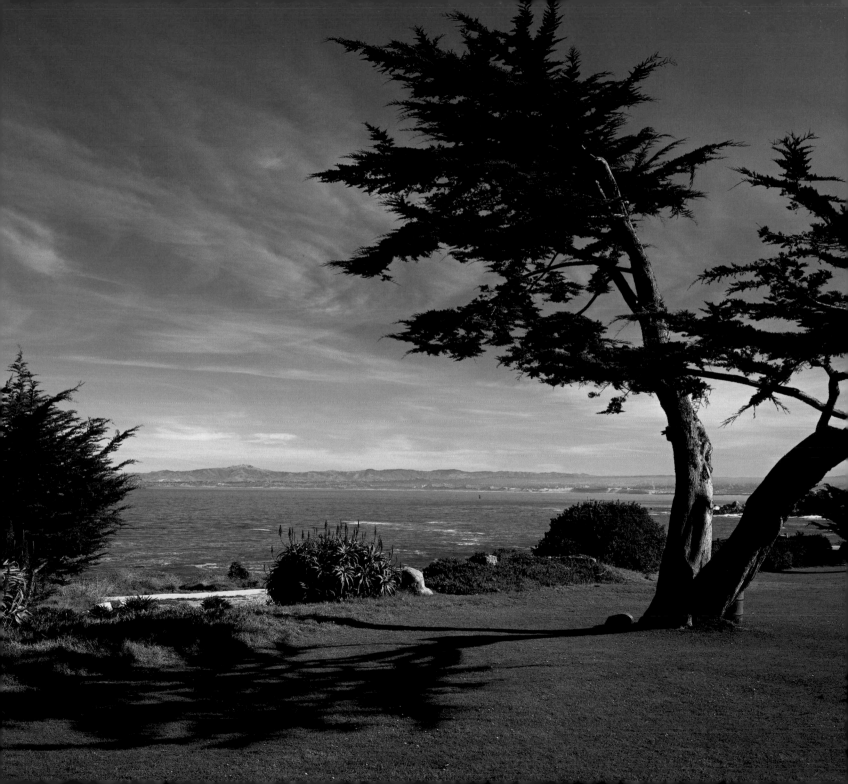

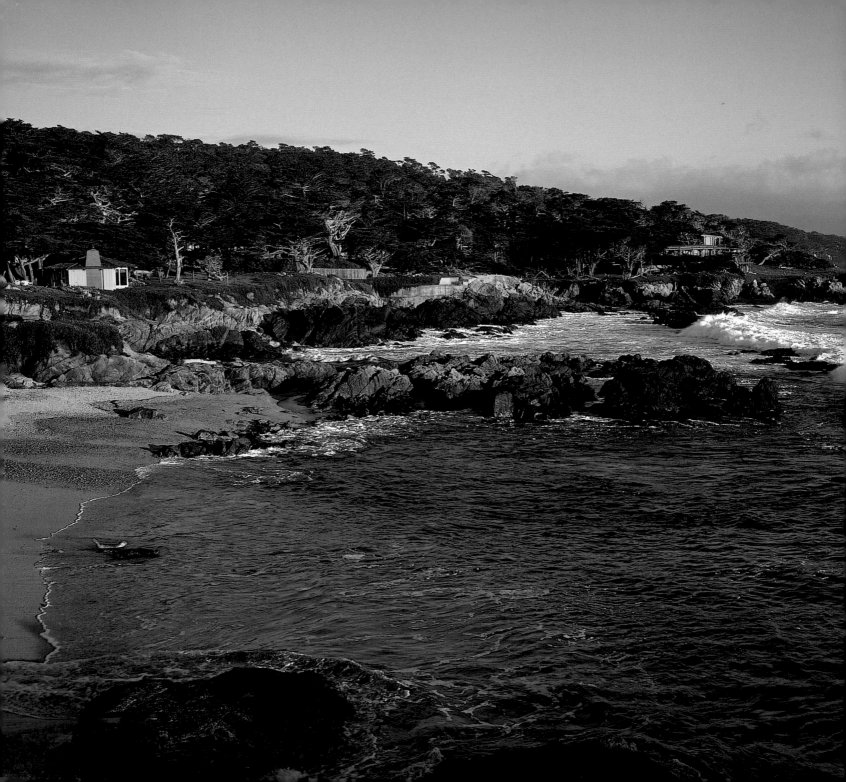

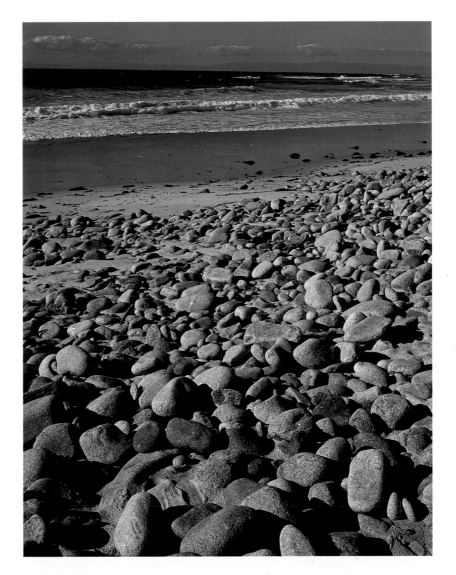

Above: Surf-worn boulders at Asilomar State Beach in Monterey Bay.

Left: 17-Mile Drive offers travelers spectacular vistas of rugged California coastline and Del Monte Forest.

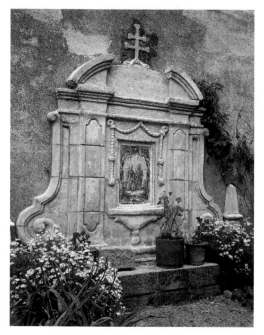

Above: One of four stone California missions, the Carmel Mission was built over 4 years and decorated by local artisans.

Above: Rose vines climb along a masonry wall in the courtyard of the mission.

Above: Flowers border the walls of the mission, which Father Serra made his personal headquarters.

Facing page: A Moorish influence is evident in the arched ceiling and the rounded bell tower of the church.

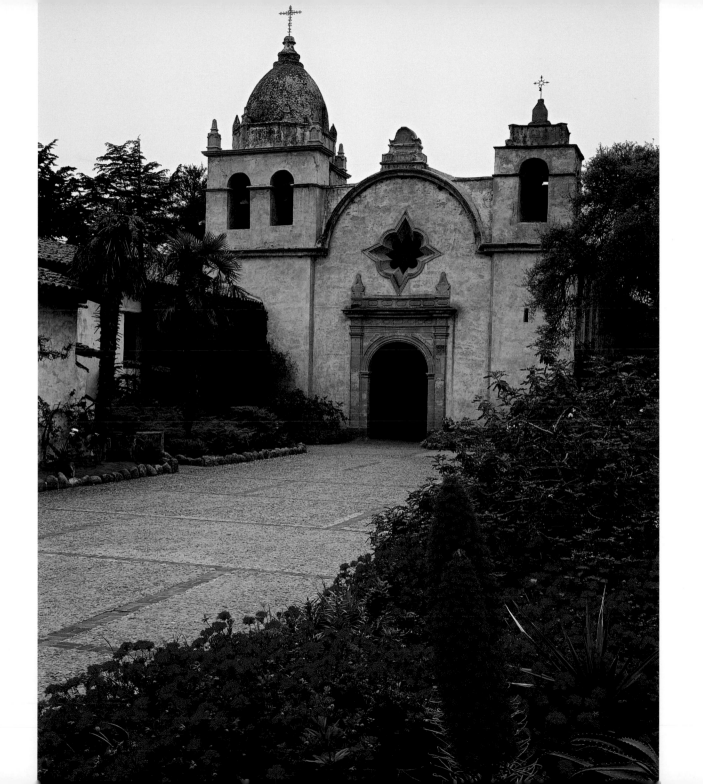

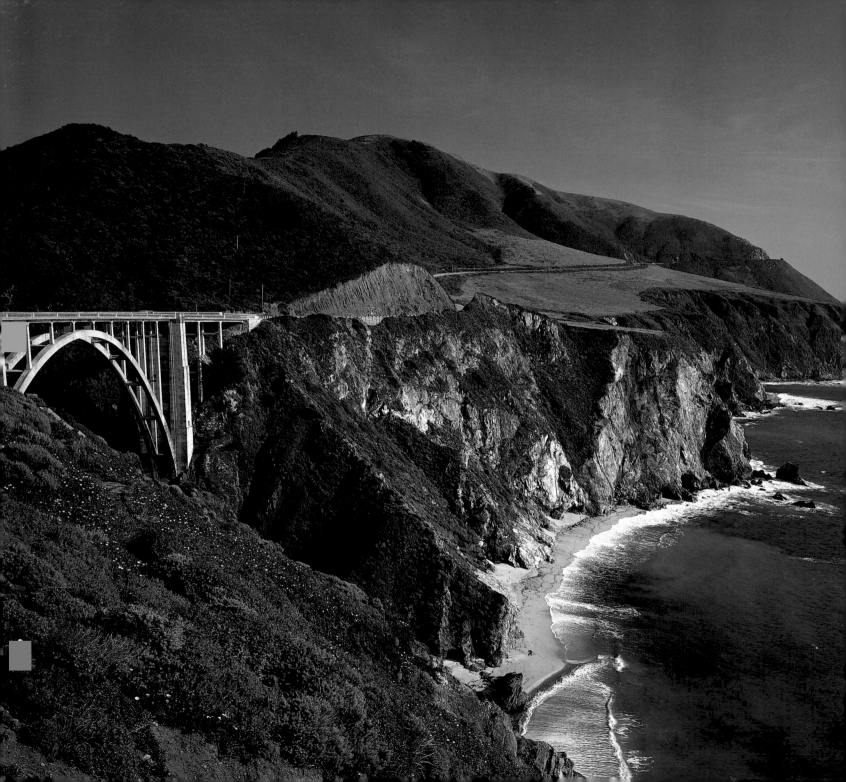

Left: Located on Highway 1 along the dramatic Big Sur coastline, the 714-foot Bixby Creek Bridge was one of the largest single-arch bridges when it was completed in 1934.

Below: Pampas grass, a native of South America, adds stability to the steep hillsides along the Big Sur coast.

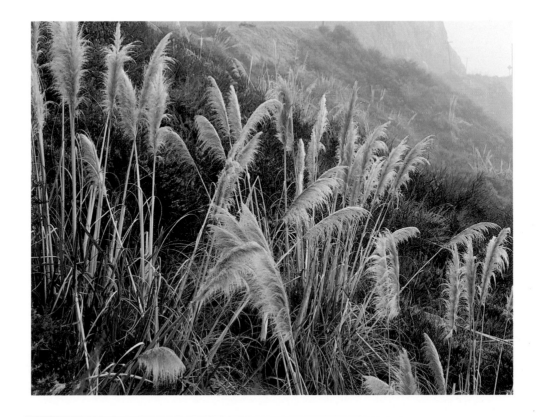

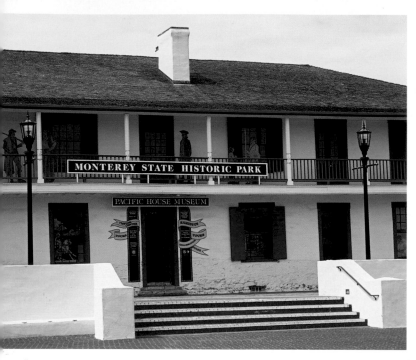

Facing page: Spring flowers adorn a walkway near Friendly Plaza on the grounds of Colton Hall, Monterey's city hall.

Below: The Merritt House was built as a private residence in 1830, but it is now a bed and breakfast inn.

Above: The Monterey State Historic Park houses the Pacific House Museum. Built in 1847, the building was a hotel, courthouse, and tavern before it became a museum that features displays about historic Monterey.

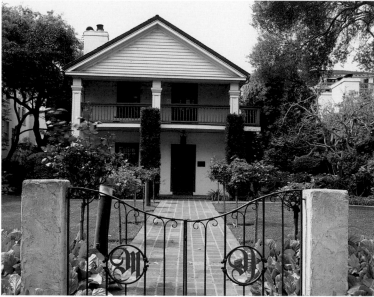

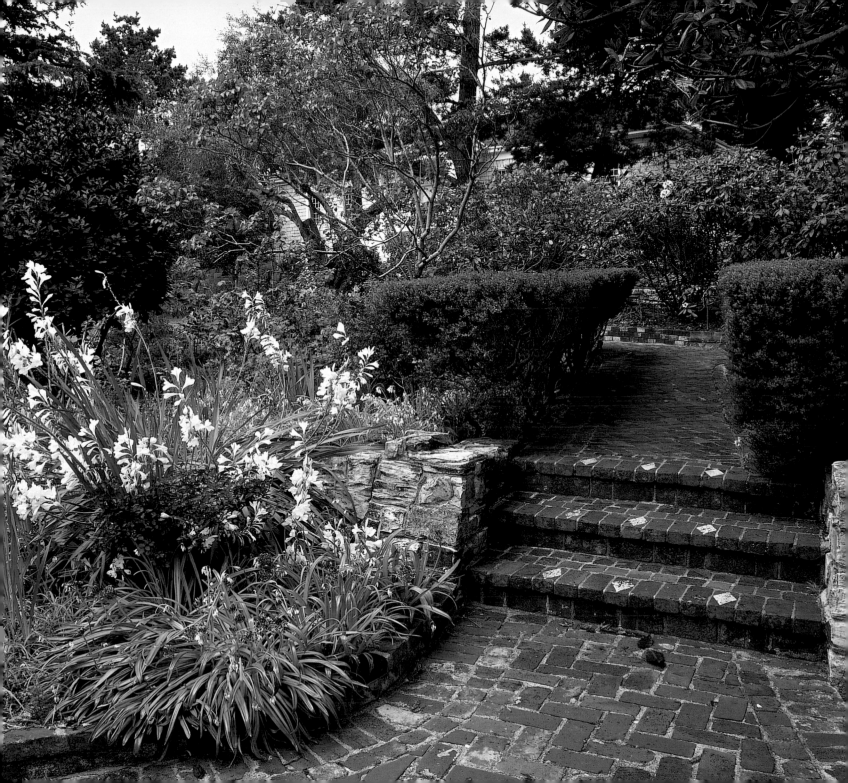

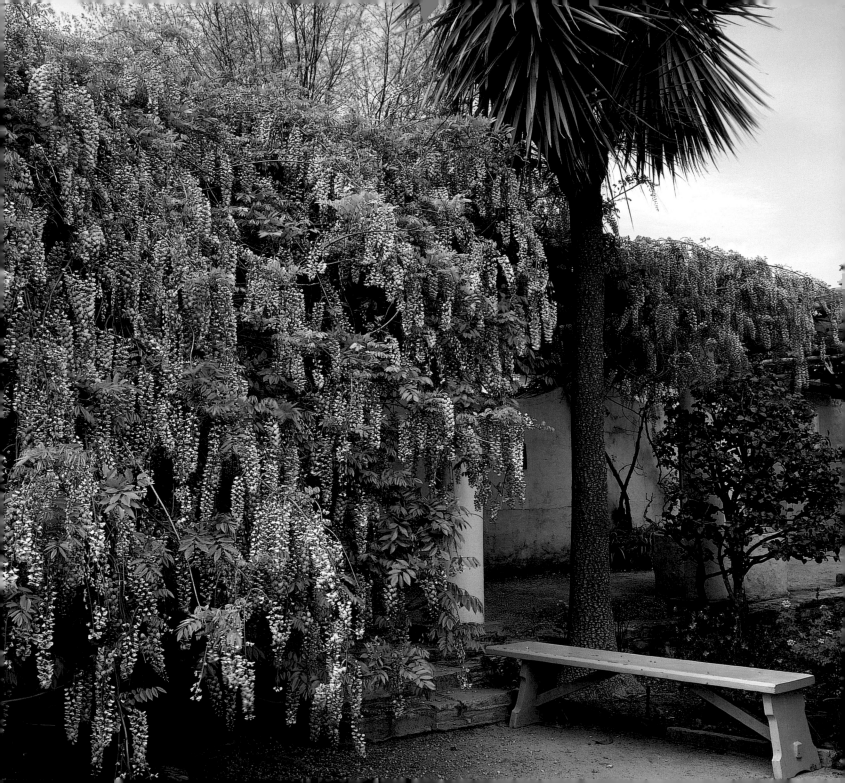

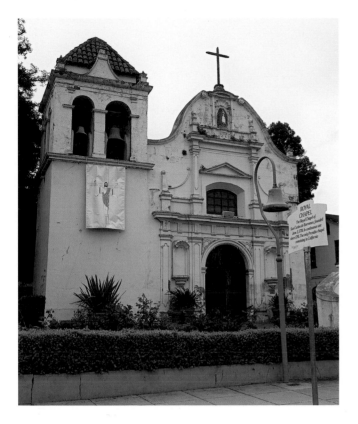

Above: The Royal Presidio Chapel, also known as the San Carlos Cathedral, was completed in 1794 and is the oldest extant building in Monterey.

Facing page: Wisteria trails down the adobe walls of the Memory Garden in the 1835 Custom House Plaza—a peaceful contrast to the bull and bear fights that were once held there.

Below: The Chateau Julian Wine Estate in the Carmel Valley is one of many wineries in the area that is a wine-growing region similar to the Bordeaux coast of France.

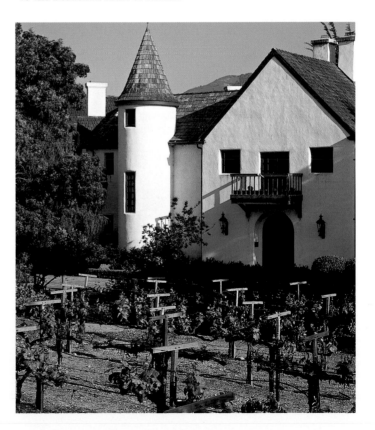

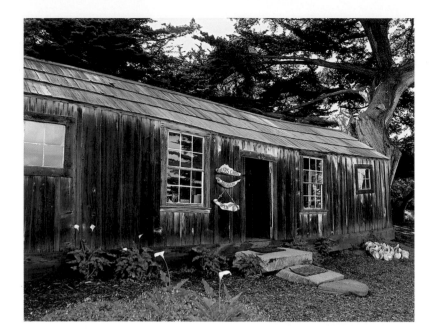

Right: This giant cypress has managed to survive despite being whipped by wind and salt spray from the Pacific Ocean.

Above: Displays and artifacts from the 1862 Portuguese whalers are exhibited at the Whalers Cabin Museum in Point Lobos State Reserve.

Right: The Cypress Grove Trail in Point Lobos State Reserve winds through one of only two remaining stands of native Monterey cypress.

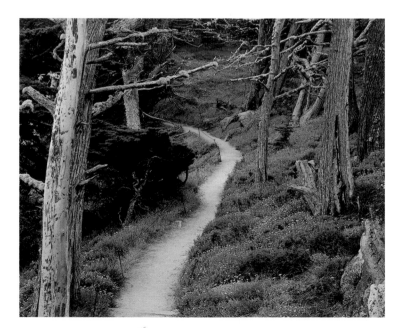

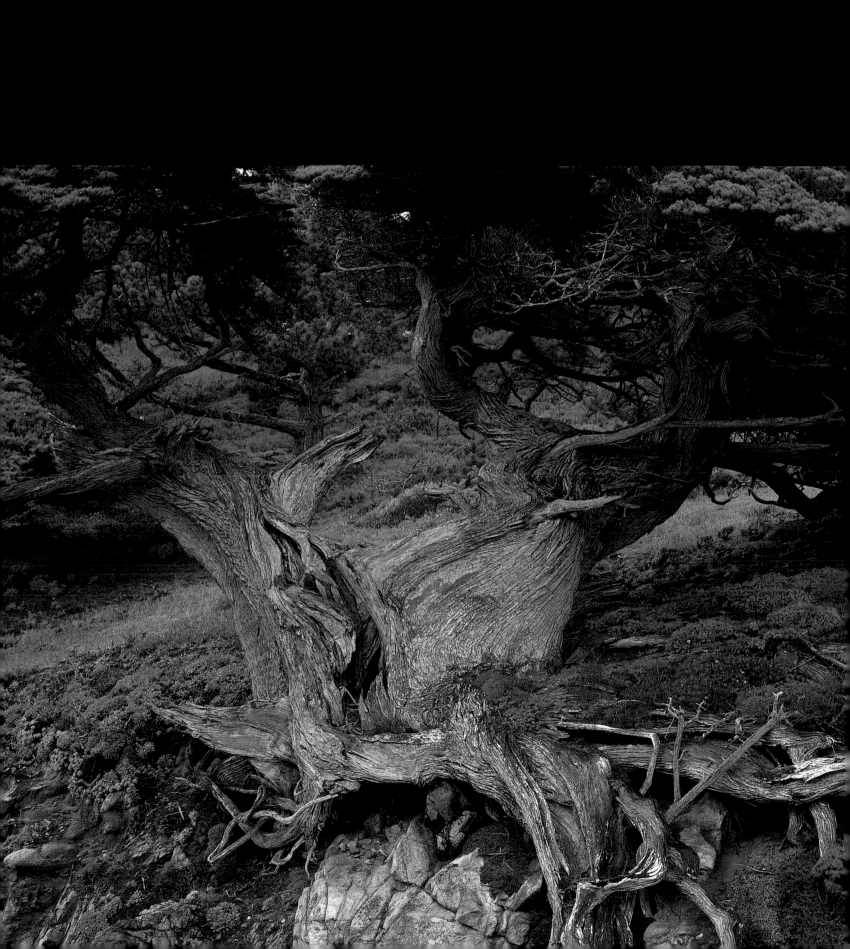

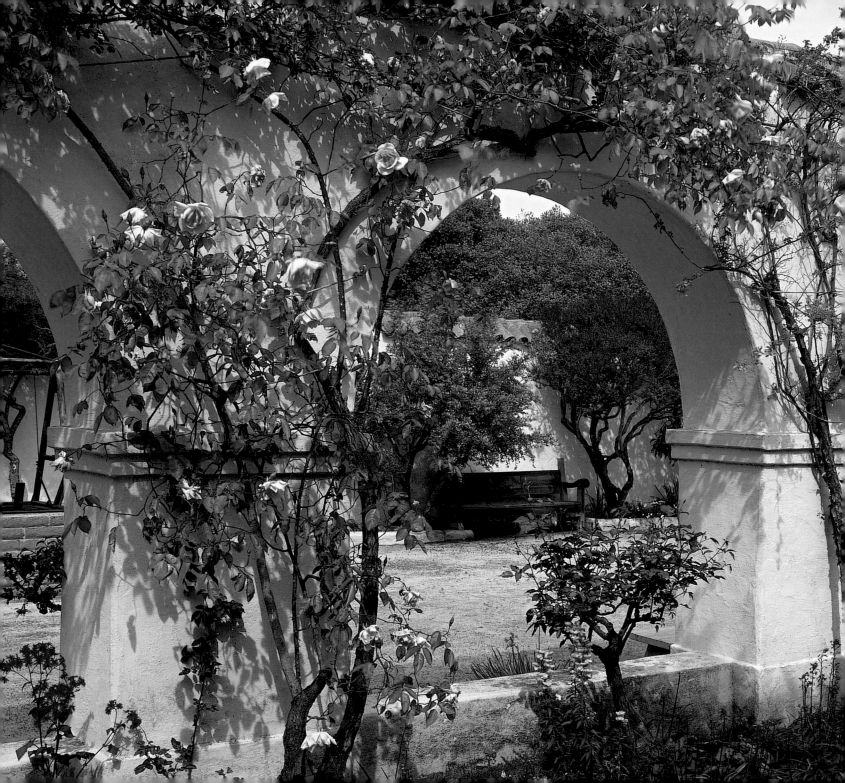

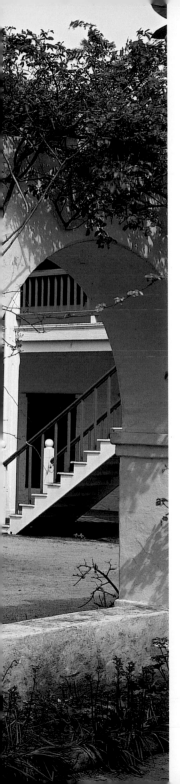

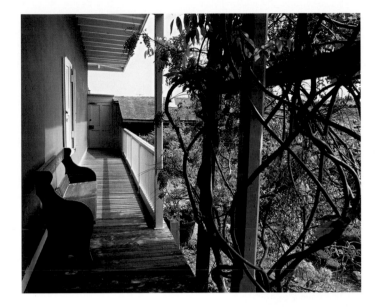

Left: Wisteria entwines the porch of the Cooper-Molera Adobe, an 1827 home that housed three generations of a sea merchant's family.

Below: Ferns adorn the gardens of the 1833 Stokes Adobe in Monterey's historic district that now serves as a restaurant and bar.

Following pages: An inspiring vista of rocky headlands, green pastures, and the Rocky Creek Bridge in the distance make the Big Sur coast along Highway 1 incomparable.

Left: Climbing roses grace the arched walls of the Memory Garden at Pacific House, the most visited garden in Monterey State Historic Park.

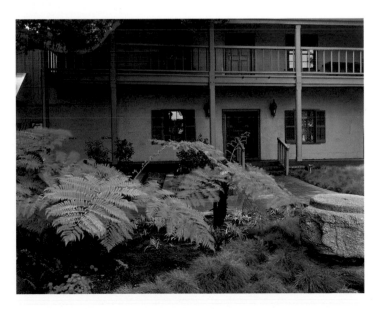

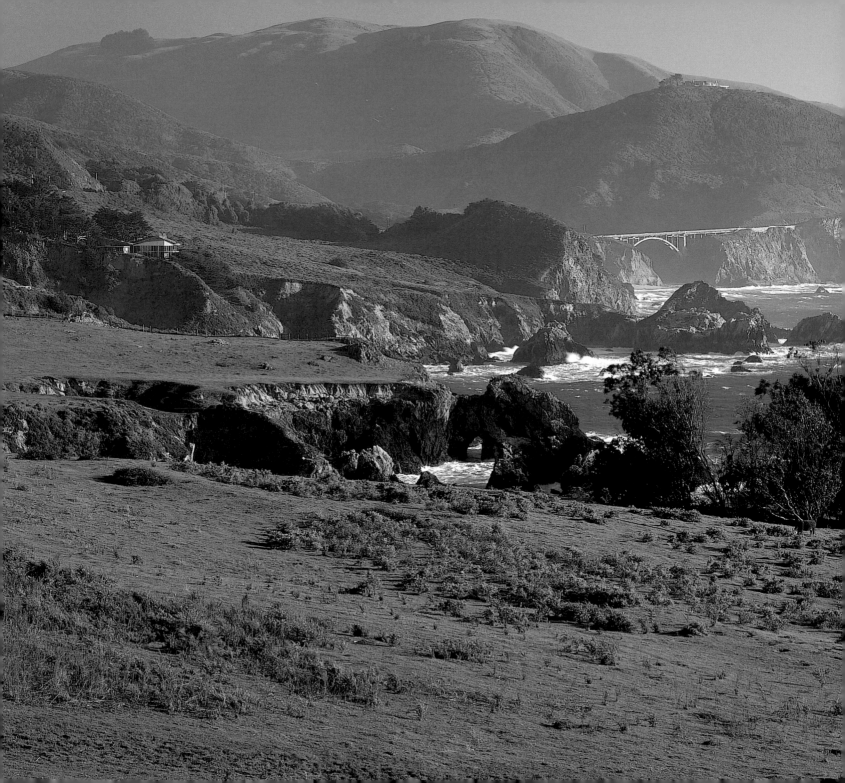

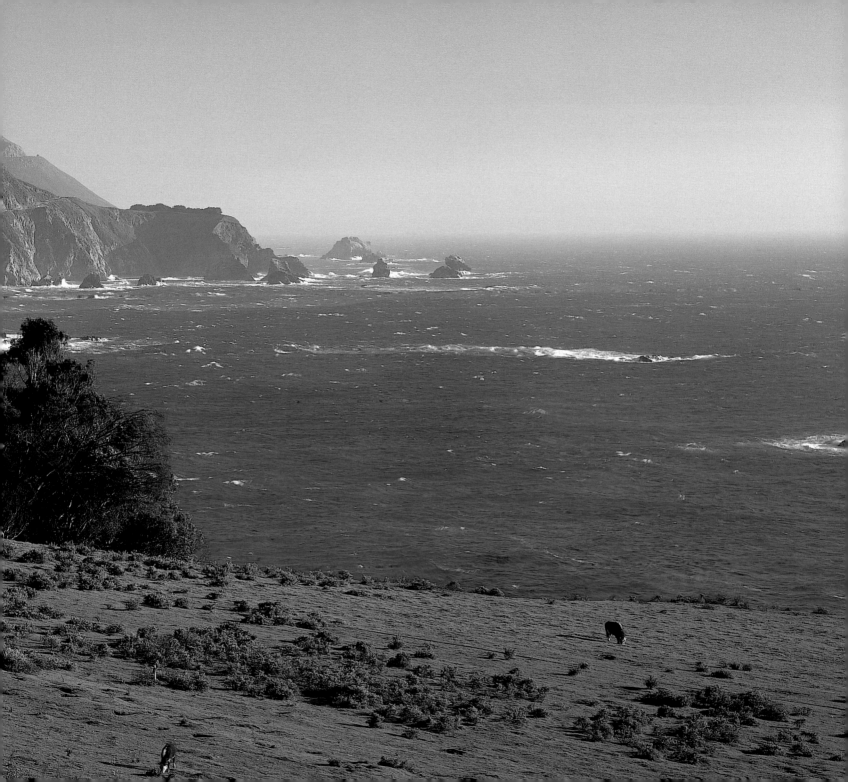

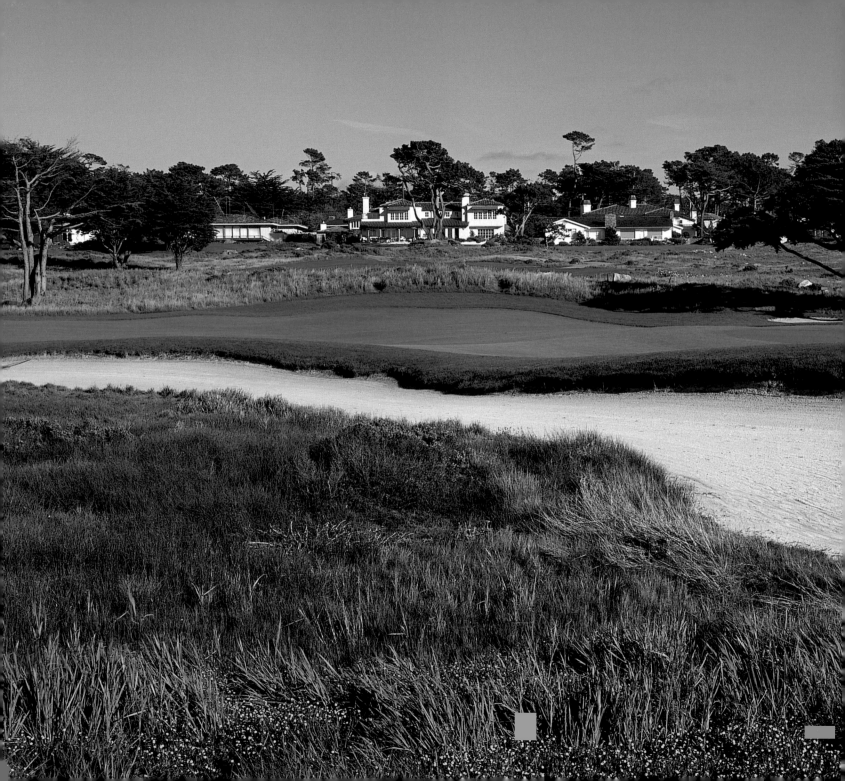

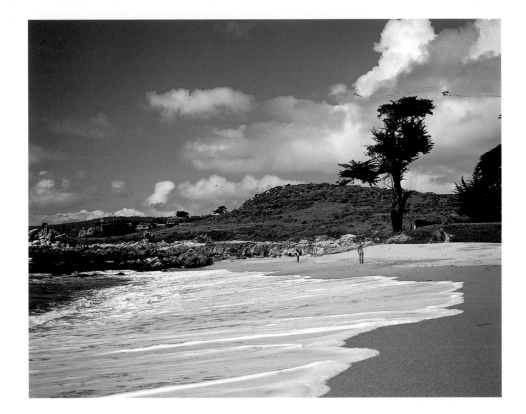

Above: Surf spills out across the broad, sandy shores at Carmel River State Beach as visitors harness the winds to fly kites.

Left: The 18-hole Monterey Peninsula Country Club, along the lovely 17-Mile Drive, features an excellent oceanside course.

Right: Surf plays out upon a sandy cove, providing endless enjoyment for visitors to 17-Mile Drive at Pebble Beach.

Below: Nature's canvas of eroded sandstone, created by timeless wave action at Point Lobos State Reserve.

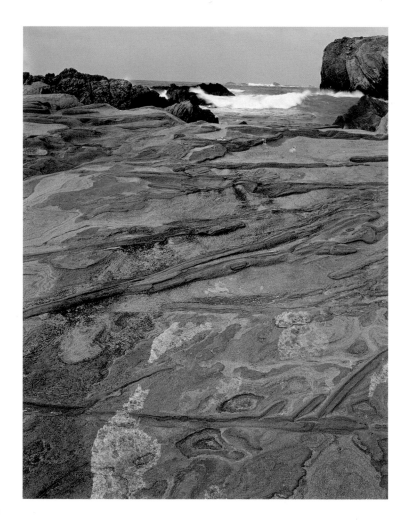

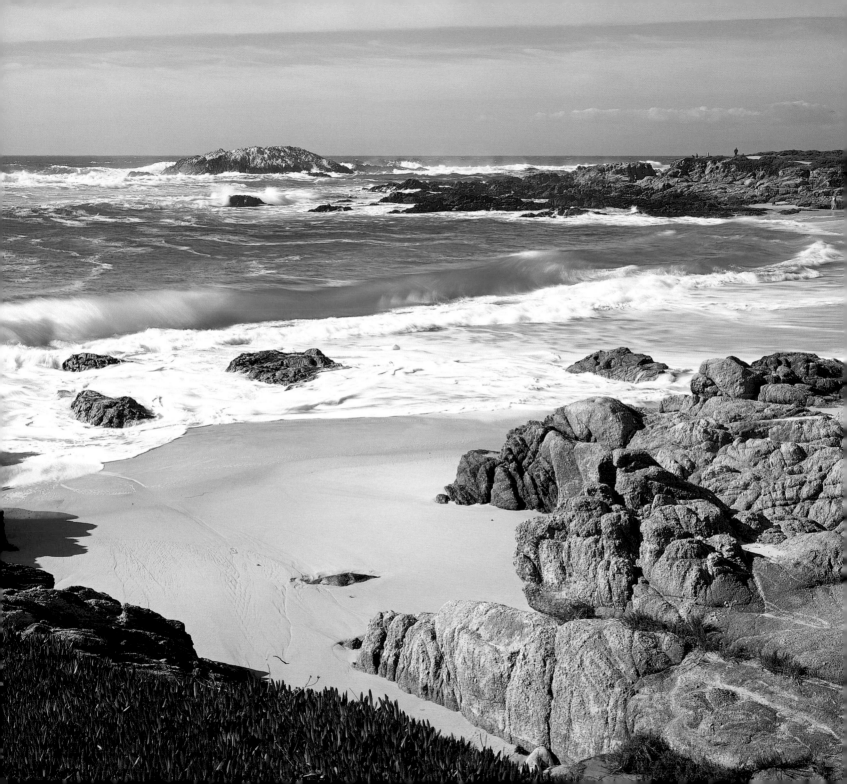

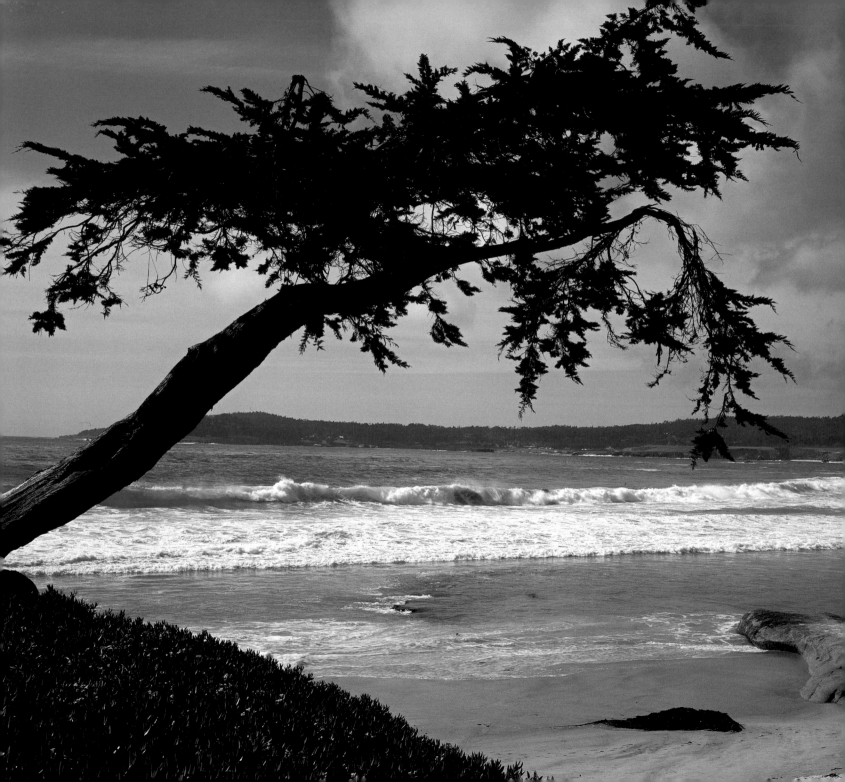

Above: The Pacific Grove Museum of Natural History features permanent as well as changing exhibits on the animals, plants, geology, and aboriginal populations of Monterey Country.

Right: Built as a lodging house and tavern in 1847, the First Theatre became a theater for U.S. Army officers in 1850, with whale-oil lamps for lights and blankets for curtains.

Left: This lone cypress tree, weathered from years of storms, frames a view of Carmel Bay.

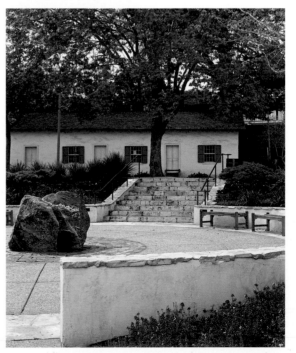

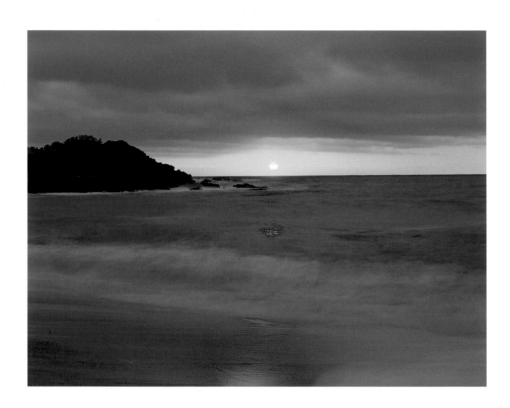

Above: Sunset casts Carmel River State Beach in a wash of color.

Right: This flower-lined pathway leads to popular Carmel State Beach.

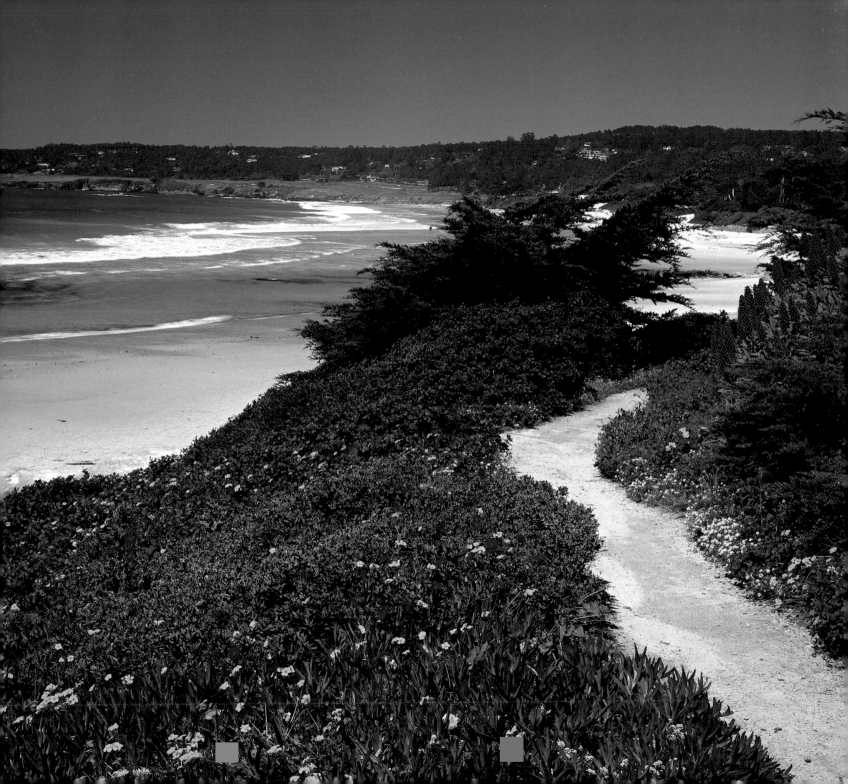

James Randklev

Master landscape photographer James Randklev has photographed America for thirty years, primarily with a large-format camera that provides the rich images collected in this volume. His brilliant and sensitive work has made him one of the Sierra Club's most published photographers. His color photographs have appeared in books, periodicals, calendars, and advertising—and they have been exhibited in the International Exhibition of Nature Photography in Evian, France. In 2003 Randklev was selected to be included a book entitled *World's Top Landscape Photographers and the Stories Behind Their Greatest Images* by Roto Vision Publications, London, England. Randklev's photography books include *In Nature's Heart: The Wilderness Days of John Muir; Georgia: Images of Wildness; Wild and Scenic Florida; Georgia Impressions; Georgia Simply Beautiful; Olympic National Park Impressions; Florida Impressions; Florida Simply Beautiful; Tucson Impressions; Arizona Impressions;* and *Bryce Canyon National Park Impressions.*

More of James Randklev's imagery can be viewed at www.JamesRandklev.com